IMAGES of America
AFRICAN AMERICANS OF DENVER

ON THE COVER: Pictured here is the Ancient Egyptian Arabic Order, Nobles of the Mystic Shrine, commonly known as the Shriners. The Denver chapter of Shriners gathered for a formal dinner as part of their annual convention. Notice the gentlemen in uniform on the right side of the photograph. At the beginning of the convention, Shriners from all over the country marched in uniform in a parade that began at city hall, traveled to Sixteenth Street, proceeded down Welton Street, through the Five Points neighborhood, and ended at Downing Street. (Courtesy Black American West Museum [BAWM], Paul W. Stewart Collection.)

IMAGES of America
AFRICAN AMERICANS OF DENVER

Ronald J. Stephens, Ph.D., La Wanna M. Larson,
and the Black American West Museum

ARCADIA
PUBLISHING

Copyright © 2008 by Ronald J. Stephens, Ph.D., La Wanna M. Larson, and the Black American West Museum
ISBN 978-0-7385-5625-3

Published by Arcadia Publishing
Charleston, South Carolina

Printed in the United States of America

Library of Congress Catalog Card Number: 2007940250

For all general information contact Arcadia Publishing at:
Telephone 843-853-2070
Fax 843-853-0044
E-mail sales@arcadiapublishing.com
For customer service and orders:
Toll-Free 1-888-313-2665

Visit us on the Internet at www.arcadiapublishing.com

This book is dedicated to the compassionate pioneering spirit of Dr. Justina L. Ford, M.D., and to Paul W. Stewart, whose inspired entrepreneurial and preservationist initiatives have made an incalculable impact on the documentation of African American life, culture, and heritage in the Old West.

CONTENTS

Acknowledgments		6
Introduction		7
1.	Touring Denver	11
2.	Paris on the Platte	17
3	Up from Slavery	31
4.	Fields Dear to Us	35
5.	Town Hall of Five Points	43
6.	Brothers as God Intended	53
7.	Those Who Suffer Write the Music	81
8.	Foot Soldiers for Freedom	95
9.	300 Miles to Victory	101
10.	Turning Disadvantages into Advantages	121
Bibliography		127

Acknowledgments

This book would not be possible without the support and encouragement of several individuals who unselfishly gave their time, energy, expertise, and resources. On the top of this list, we want to gratefully acknowledge Hannah, our editor at Arcadia Publishing, for believing in this project. We also want to thank fellow Black American West Museum board members for supporting our efforts and all the time away from board business we devoted to complete this book. We especially want to acknowledge the unselfish love and support of La Wanna Larson's family: Donald Larson, husband; Jaculine, sister; Jack, father; Loris, mother; Hannah, niece; and Elizabeth Spann, niece, for the many hours they gave to this project. Without their assistance and support, we would still be working.

We would especially like to thank Paul W. Stewart for the documentation and rare photographs of the Paul W. Stewart Collection of the Black American West Museum. Many thanks to the faculty of the Department of African and African American Studies, to the staff of College Communications, and to Metropolitan State College of Denver. The support provided through the civic engagement activities of Dr. Ronald J. Stephens and through permission to reprint a photograph taken by Julie Strasheim reinforced the college's position in supporting projects of this type. We are so thankful for the support of Terry Nelson, archivist of the Blair Caldwell African American Research Library; Peggy Wortham, office manager of Colorado's Black Chamber of Commerce; Wellington Webb, president of the chamber; his wife, Wilma Webb; and Cindy Brody, Wellington Webb's publicist. We thank Bee Harris of Urban Spectrum, Carl Bourgeois and Shelia King of Civil Technologies, Linda Williams of the African American Leadership Institute, Cheryl Armstrong of the James P. Beckwourth Mountain Club, Brother Jeff, and Sid Wilson.

Many thanks to Terri Smith Gentry, who provided significant insights on the history of the McClain, Smith, and McLuster families in Denver and other topics. We also recognize the research efforts and arrangement of historical documents about the Five Points neighborhood performed by Sarah Moore of Metropolitan State College of Denver.

Finally, we want to recognize the many stakeholders who have supported the Black American West Museum for the past 40 years. Of course, this book does not represent a comprehensive photographic treatment of African American culture, life, and history in the greater Metropolitan Denver community. We hope, however, that our readers will find it a worthy source of information and an inspiration to better understand the people, institutions, and community of African Americans of Denver.

INTRODUCTION

As Katharine Lee Bates gazed down from the top of Pikes Peak, struck by the aesthetic beauty of the panoramic vista of the Colorado Plains at the foot of the majestic Rocky Mountains, she "felt great joy [as] all the wonder of America seemed displayed there, with the sea-like expanse." The lyrics of Bates's "America the Beautiful" were sentiments reflected in the hearts and minds of African Americans who were reconstructing their lives after slavery.

Against the backdrop of intimidation and bloodshed, every success was a testament to the pioneering spirit that beckoned black citizens to migrate west. Denver was founded during the Pikes Peak gold rush in the Kansas Territory on November 22, 1858, when Gen. William Larimer, a land speculator from eastern Kansas, placed cottonwood logs to stake a claim on the hill overlooking the confluence of the South Platte River and Cherry Creek. Larimer named the town site Denver City after Kansas Territory governor James W. Denver. Gold, silver, land, and a chance at self-sufficiency drew all ethnic and economic backgrounds west. At first, Denver was a mining settlement where prospectors panned gold from the sands of nearby Cherry Creek and the South Platte River. The prospectors discovered that gold deposits in the streams were quickly exhausted. Denver City became an instant ghost town until the discoveries of George A. Jackson and John H. Gregory—rich gold deposits in the mountains west of Denver in 1859, which ensured Denver's future as a supply hub for the mines in the mountains.

As citizens migrated west in the late 1800s, the Homestead Act of 1862 offered land to anyone who could farm it for five years. The act, which became law on January 1, 1863, allowed citizens to file for 160 acres of free land. For African Americans, this meant freedom and the opportunity to acquire land and build an independent life. After the Civil War, black men had attempted to vote and hold office as though they lived in a democracy, even though the principles of democracy were severely limited for them. To acquire land during and after Reconstruction enabled them to build their own institutions, which planted seeds well into the 1890s. Historian Nell Painter observed that although the promise of black freedom and civil rights ended when the southern and border states enacted policies that effectively disfranchised them, African Americans rushed west to find their destiny. The West offered a chance of self-determination and an escape from persecution.

The Exodusters, a designation to African Americans who fled the South, migrated to Nicodemus, Kansas, in 1879 and 1880 as racial oppression and rumors of the South's reinstitution of slavery led African Americans to settle there because of its fame as the land of abolitionist John Brown (1800–1859). The state was reputed to be more progressive and tolerant than others and was known for the political efforts of such separatist leaders as Benjamin "Pap" Singleton. Some Exodusters died along the way, and many traveled no further than St. Louis, Missouri. Those who escaped the Deep South found Kansas to be a place where they could send their children to good schools, vote and hold office, and acquire their own land. Although racial violence occurred in late 19th- and early-20th-century Kansas, it did not compare to the rampant violence in the South.

African Americans moved west as fur traders, mountain men, guides, miners, buffalo soldiers, pioneers, cowboys, farmers, entrepreneurs, doctors, lawyers, and business people. They used all

forms of transportation, including wagon trains, railroad, stagecoaches, handcarts, horses, and their own feet. They lived in tents, sod houses, log cabins, caves, tar paper shacks, and clapboard homes. Once in Denver, they scattered throughout the city and into the Cherry Creek area. They created black colonies while working jobs during the week and farming their homesteads in towns like Dearfield on the weekends. They spent their holidays at Winks Lodge and their summers at Camp Nizhoni.

After a lifetime of servitude, Clara Brown was freed in 1856 in her owner's will. Brown made her way to Kansas, and by 1859, she was hired by a group of prospectors heading to Pikes Peak as a cook. Eight weeks later, she arrived at Cherry Creek, where she worked as a nurse, cook, and laundress. Denver City was across the South Platte River from the site of seasonal encampments of the Cheyenne and Arapaho. It was a frontier town, its economy based on servicing local miners with gambling, saloons, livestock, and goods trading. E. J. Sanderlin came to Colorado in 1859 and opened one of the first barbershops and restaurants in Denver. Barney Lancelot Ford, an escaped slave, arrived in Colorado in 1860 and fought against Colorado statehood until African Americans were permitted the right to vote. In 1865, Denver City became the territorial capital and shortened its name to Denver. On August 1, 1876, Denver became the state capital when Colorado was admitted to the Union. The completion of the Denver Pacific and Kansas Pacific rail lines in 1870 helped Denver become a major trade center for the West. This small, dusty town along the Platte River became the third largest city in the West. By 1890, Denver had a population of 106,713. The 1890 U.S. Census reported that about 6,000 African Americans lived in Colorado, with about 5,000 owning property. Of those 6,000, 3,254 lived in Denver.

Curtis Park was one of Denver's first subdivided parcels. German, Irish, and Jewish immigrants and African Americans of wealth relocated far away from the city in the wide-open prairie. Many escaped the crowded congestion of Denver to the carefully manicured suburbs. By 1881, Five Points was named for the five-way intersection of Welton Street, Twenty-seventh Avenue, Washington Street, and Twenty-sixth Street. By the 1890s, Curtis Park was considered an elegant streetcar suburb of Denver. As other suburbs were built, the wealthy moved to prominent neighborhoods such as Capitol Hill, and African Americans settled in larger numbers in Five Points. In 1893, Fire Station No. 3, which was located in the heart of the Five Points neighborhood, became the first all-black fire station in Denver.

By the early 1900s, restrictive housing covenants and Jim Crow segregation forced the majority of African Americans to live in the Five Points neighborhood. Others settled in neighborhoods scattered throughout the Denver metropolitan area. The black community of Denver thrived with the pioneering efforts of Thomas Ernest McClain, Colorado's first black licensed dentist, and Lewis Douglass and Frederick Douglass Jr., sons of the famous abolitionist Frederick Douglass, signers of the famous 100 Blacks Petition for the right to vote for African Americans, and helpers in the creation of the first black school in Denver. Walker Anderson's family migrated to Denver in the 1870s, and he became a pioneer builder and miner, and assisted in the construction of the Central City Opera House, the Antler's Building, the Denver Courthouse, Daniels and Fisher Tower, the State Capitol, and the Rio Grande Building. Francis T. Bruce was a policeman listed on the Denver police roster in the 1890s and helped to organize the black Masonic Lodge.

As Denver's overall population grew, Five Points became the heart of the black community and played an important role in the social, political, and economic history of African Americans. The period marked a number of changes and challenges for the Five Points neighborhood as the black business sector of the community matured into a fairly significant force. The 1920 U.S. Census indicated that 6,075 African Americans resided in Denver, an increase of 649, or 12 percent, from 1910. Continued migration from the South created a political, economic, and cultural base for businesses in Five Points. The migration of attorneys, physicians, surgeons, embalmers, and farmers helped. With the establishment of Douglass' Undertaking, the Rossonian Hotel, and Atlas Drug Store in 1911, Welton Street from Twenty-second to Twenty-ninth Streets served as the main street of Denver's black community from the 1920s to the early 1970s. The Welton Street business district attracted businesses such as restaurants, tailors, real estate agencies, saloons, pool

halls, doctors, dentists, and a branch of the American Woodmen Insurance Company, which served as an important resource for residents. Laurie Simmons and Thomas Simmons illustrated how business and social arrangements were actualized.

As in other parts of the city, the emergence of a small business district, which provided for the needs of those in the immediate area, was of tremendous significance in the development of the community. Local businessmen served as role models for neighborhood children and their enterprises symbolized success and stability. Often these local businessmen became leaders within the community and were well respected among their peers. Local business establishments became meeting places for the entire community where neighborhood issues were discussed. In addition, the owners of businesses in the district aided their neighbors by extending credit and helped many survive and recover from hard times.

The social purpose businesses served emphasizes one of the bonds that held families in the community together. The area was also home to two black-owned newspapers founded in the late 19th century. The *Colorado Statesman* and the *Denver Star* "encouraged change" as they promoted "civil rights" issues. Simmons and Simmons explained how Joseph D. D. Rivers, the editor of the *Colorado Statesman* and a close friend of Booker T. Washington, "used his newspaper to encourage blacks to come west to invest in real estate and establish businesses." J. R. Smith and Lewis Price founded the *Denver Weekly Star* (later known as the *Denver Star*) in 1881 for similar reasons.

The most enduring institution to glue the community together was the church, and black churches played a pivotal role in the lives of the residents. The churches of Five Points offered incoming migrants and permanent residents a sense of place, community unity, and pride in home ownership. As elsewhere in the country, churches functioned as houses of worship, networking sites, and places where members and visitors could appreciate Christian fellowship. Black churches offered opportunities to hear meaningful sermons from their distinguished pastors and invited guest speakers. For example, Shorter African Methodist Episcopal (AME) Church, the first African American church established in Colorado (in Denver) in 1868 by Bishop Thomas M. D. Ward, a pioneer of African Methodism in the West, fulfilled multiple needs for African Americans of the Five Points area. The Scott Methodist congregation, which traces its roots to 1904, was established as Denver's only United Methodist denomination to welcome African Americans.

Racial segregation was pervasive in Denver. So too was the Ku Klux Klan. Born alongside D. W. Griffith's film, *The Birth of a Nation*, the Klan in Denver was organized during the early 1920s, functioning, according to historians Carl Abbott, Stephen J. Leonard, and David McComb, authors of *Colorado: A History of the Centennial State*, as a blow against outsiders who were pushing their way into positions formerly held by native-born citizens. Jews and African Americans with a modicum of self-respect were bad enough. Roman Catholics were worse—they represented the spearhead of a conspiracy against the Puritan civilization that had made the country great. At the same time, the average Klan member worried about the peace of his community and the honor of his daughter.

The fear of change and cultural difference was the driving force that inspired the Klan. The changing demographics of home owners and, to some extent, employment dynamics accelerated racial and religious tensions in Denver.

In its first year, Denver's Klan followed the national pattern, mixing petty violence and harassment with conviviality. For Friday night entertainment, Klan members routed auto caravans through the Jewish neighborhood on West Colfax, honking horns and shouting insults. The local NAACP suffered Klan threats, and at least one African American who allegedly failed to observe the code of interracial contact was driven out of town.

Klan participation of the 1920s, according to Laura Mauck, was "at an all time high" as some "fifty thousands Coloradans" became members, "making it second only to Indiana." Some members were even elected officials such as Colorado's governor Clarence Morley, who served from 1925 to 1927; Denver's mayor Benjamin Stapleton, who served from 1923 to 1931; and the chief of police. Mauck adds, "Communities surrounding Five Points formed Neighborhood Improvement Associations, which created covenants that banned residents from selling their homes or property

to non-whites." The political climate in Colorado during the Progressive Era left African Americans with no choice but to create internal Progressive Era opportunities, which developed as a result of a series of progressive, new Negro thinkers such as Marcus Garvey, W. E. B. Du Bois, and James Weldon Johnson, who visited the Five Points area frequently. Garvey and his organization, the Universal Negro Improvement Association and African Communities League (UNIA-ACL), offered an abundance of hope to Denverites.

The Garvey movement illustrated how collective and individual confidence, faith, and pride can achieve African redemption. Marcus and Amy Jacques Garvey's thundering voices were not only spellbinding, persuasive, and inspiring, but also pragmatic in constructing and promoting a human civilization of racial equality. Their slogan, "Africa for the Africans," both at home and abroad, situated the African predicament on the same continuum as other global liberation movements. The couple rallied black Coloradoans to make the mental shift from a race of an inferior people to a race of superiority, a people embracing their cultural dignity, identity, independence, soul, and pride. The aims and objectives of the organization were known throughout the Five Points neighborhood.

Early references published in the *Colorado Statesman* and the *Denver Star* also indicate World War II brought wartime industry to Denver. According to an article in the *Colorado Statesman*, "President Franklin Roosevelt's Executive Order 8802, issued in response to A. Philip Randolph's threatened 1941 'March on Washington', meant that black men and women in Denver would be hired in these defense industry plants and other firms with defense contracts such as Denver's military installations—Fitzsimmons Army Hospital, Fort Logan, Lowry Air Base, and Buckley Navel Air Station—employed a sizeable number of civilian workers in the Remington Arms of Denver's Ordinance Plant, Kaiser Company, and the Rocky Mountain Arsenal."

This book illustrates many events and circumstances involving the lives of African Americans in Denver from the time when racially bigoted action was the norm, to their pioneering experiences and community spirit in metropolitan Denver brought through the activism of their participation in the civil rights movement and beyond. Today the city and county of Denver has a population of 554,636; African Americans constitute 7.9 percent of that number. The six-county metro area has a population of 2.4 million. Denver's metro population increased, as did the number of African Americans, making it the 20th largest metro area in America with the 10th largest downtown area. Denver is continuing to grow as more people discover it as a diamond in the Great Plains.

One
TOURING DENVER

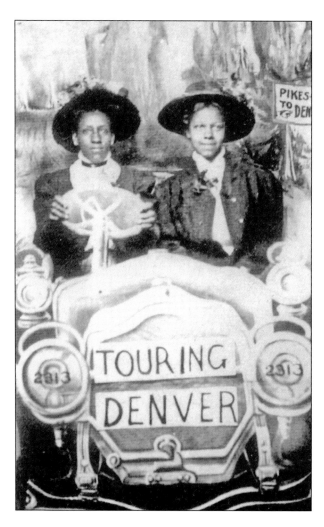

PIKES PEAK TO DENVER. Lulu Fisher (left) and Donna Nelson were touring Colorado when they posed for a picture postcard in a prop car that reads "Touring Denver." In the backdrop, a sign reads "Pikes Peak to Denver." (Courtesy BAWM, Paul W. Stewart Collection.)

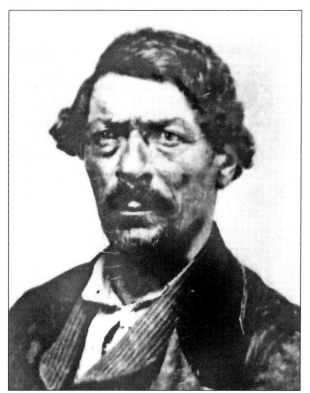

JAMES PIERSON BECKWOURTH. Born in 1798, James Beckwourth was a mountain man, fur trapper, explorer, frontiersman, Crow chief, and cofounder of the city of Pueblo, Colorado. He also discovered Beckwourth Pass in California, was a scout for the Union Army, and later a storekeeper in Denver. In 1864, Beckwourth was a guide for John M. Chivington during the Sand Creek Massacre and testified against him. (Courtesy BAWM, Paul W. Stewart Collection.)

"AUNT" CLARA BROWN. Clara Brown was born in 1800. At age 35, she was sold and separated from her family. Freed in 1859, Brown moved to Denver and then to Central City. By 1866, she had saved $10,000 and started the search for her family. A stained-glass window in the capitol and a chair in the Central City Opera House commemorate Brown's life. (Courtesy BAWM, Paul W. Stewart Collection.)

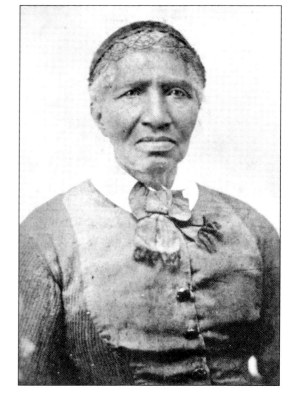

BARNEY LANCELOT FORD. Barney Ford was born in 1822. After escaping to Chicago via the Underground Railroad, he married Julia Lyoni. Ford arrived in Colorado during the gold rush, and he set up a barbershop in Denver. Ford fought against Colorado statehood until African Americans gained the right to vote. Ford served with William N. Byers and John Evans on the board of the Dime Savings Bank. (Courtesy BAWM, Paul W. Stewart Collection.)

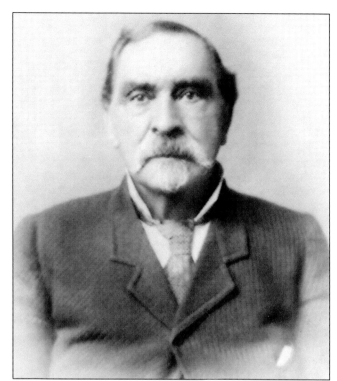

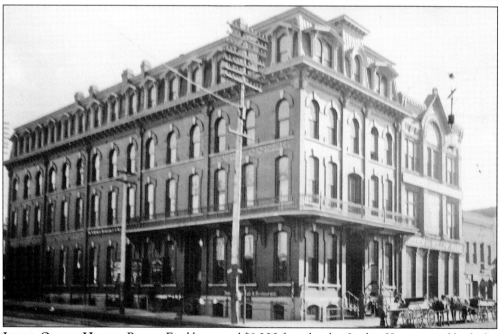

INTER-OCEAN HOTEL. Barney Ford borrowed $9,000 from banker Luther Kountze and built the People's Restaurant and later the Inter-Ocean Hotel. Ford, a member of the Colorado Association of Pioneers, is immortalized in a stained-glass window at the Colorado State Capitol. His People's Restaurant still stands at 1514 Blake Street. Pictured is the Inter-Ocean Hotel, which Ford borrowed money to build after the great fire of 1863. (Courtesy BAWM, Paul W. Stewart Collection.)

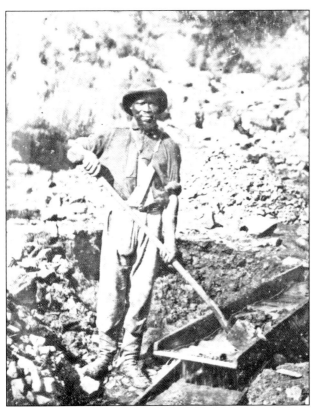

MINER. The gold rush attracted a varied African American population. Free and enslaved men, women, and children, working as janitors, porters, store clerks, barbers, drivers, intellectuals, hotel owners, barbers, cooks, cowboys, nurses, and laundresses, made Denver their home and created self-help and cultural organizations. They often sought city jobs because wages were high and the work was more dependable than prospecting. (Both, courtesy BAWM, Paul W. Stewart Collection.)

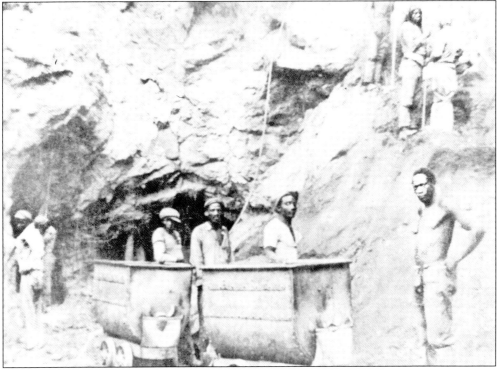

IRON DUKE MINING COMPANY. Born in Virginia, William Fountain moved to Denver in 1885 because of failing health. When his strength returned, he tried his hand at mining. Fountain worked as a president of the Western Business and Loan Association; was treasurer of the Iron Duke Mining Company; managed the American Club, a social club; and was an employee of the Arapahoe County Court in 1891. (Courtesy BAWM, Paul W. Stewart Collection.)

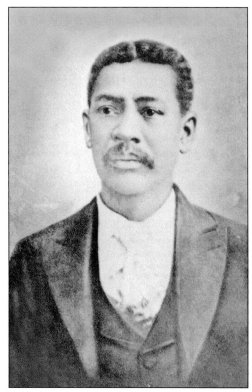

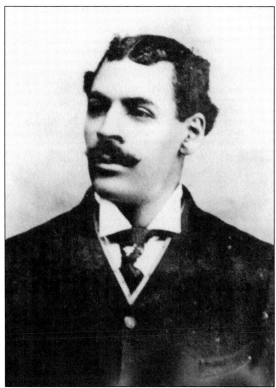

COLORADO STATESMAN. Edwin H. Hackley graduated from law school in Michigan in 1883. After moving to Denver in 1884, he passed the Colorado Bar, becoming one of Colorado's first lawyers. Hackley organized the *Colorado Statesman* but later sold his interest to G. F. Franklin. His wife, Azalia, was the first African American graduate from the University of Denver College of Music in 1899. Hackley was also a playwright, poet, and musician. (Courtesy BAWM, Paul W. Stewart Collection.)

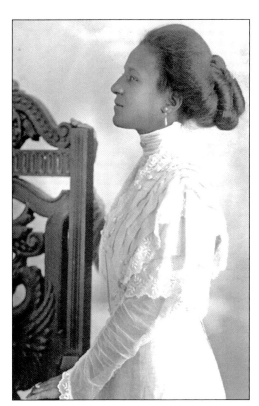

JESSIE ANDREWS. African American women like Jessie Andrews actively created and maintained churches, literary societies, women's clubs, and civil rights organizations. They also promoted education, respectability, and reform. The Colored Ladies Legal Rights Association challenged racial discrimination in Denver in the early 1870s. African American women also sought cultural and intellectual improvements, self help, and moral rectitude. In her speech, the president of the Colorado Association of Colored Women's Clubs challenged members to "lift a down trodden race above the Rockies of prejudice." Ida DePriest cofounded the Colored Women's League of Denver under the National Association of Colored Women's Clubs. The club's motto, "Lifting as We Climb," expressed the club's commitment to African American children's education. (Courtesy BAWM, Paul W. Stewart Collection.)

Two

PARIS ON THE PLATTE

DENVER WEEKLY STAR. Wellington Randolph was born in Virginia and moved to Denver in 1872, where he married Cherry and joined Denver's first volunteer fire department. Randolph, J. R. Smith, and Lewis Price published the black newspaper called the *Denver Weekly Star* in 1881. The department store Daniels and Fisher hired Randolph as one of its first watchmen. The Daniels and Fisher Tower still exists at Sixteenth and Lawrence Streets. (Courtesy BAWM, Paul W. Stewart Collection.)

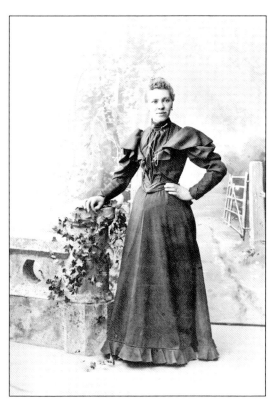

ADVENTUROUS WOMEN. African American frontier women immigrated to the Wild West and helped "civilize" it by creating churches, social groups, and schools, and by providing community services. They also supplied much needed skills as cooks, nannies, housekeepers, nursemaids, laundresses, and shopkeepers. African American women also followed their husbands and fathers west, working side by side as miners, farmers, and cowhands. (Courtesy BAWM, Paul W. Stewart Collection.)

NAACP. As a young child, Daisy Jones escaped slavery to Canada, where she received her medical education. Jones moved to England, where she practiced until she arrived in Denver in 1903 to be a nurse. In 1913, Jones was an early organizer of the Denver chapter of the National Association for the Advancement of Colored People. (Courtesy BAWM, Paul W. Stewart Collection.)

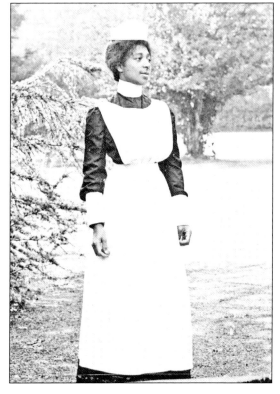

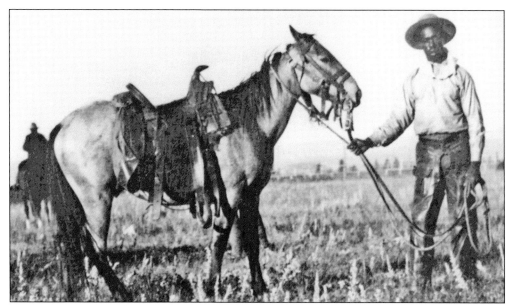

BANK ROBBER. According to the 1870 census, Diamond Dan Sr. (also known as Diamond Anderson or the Black Diamond) was the first known African American cowboy in Colorado. During the 1870s, while herding cattle in Trinidad, he was laid off. Diamond robbed a bank in Denver and was trailed by a posse to Greeley, where he was arrested, tried, and sent to jail. (Courtesy BAWM, Paul W. Stewart Collection.)

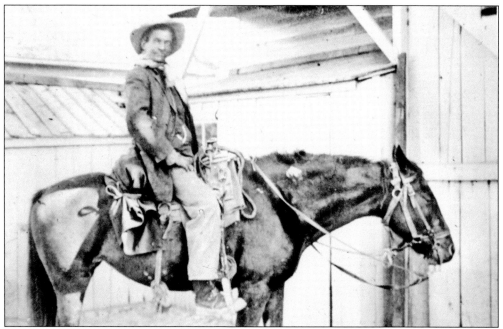

BENJAMIN FRANKLIN. A government employee for nearly 40 years, Franklin served with the war department during the Civil and Spanish-American Wars. Franklin came to Colorado with Kit Carson in 1861 and worked as a trader, trapper, and interpreter. He also operated the first hack service in Fort Logan. Franklin's Crossing is named after him. He died at the age of 82. (Courtesy BAWM, Paul W. Stewart Collection.)

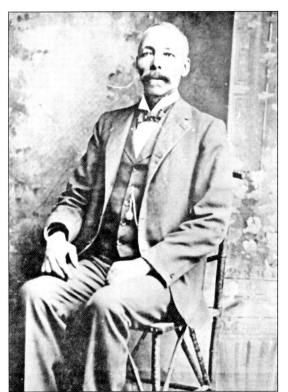

RELIGIOUS ACTIVIST. Thomas J. Riley was the first Sunday school superintendent at Shorter African Methodist Episcopal (AME) Church. Riley also served as the cofounder of Denver's Zion Baptist Church and the cofounder of the Denver Masons. (Courtesy BAWM, Paul W. Stewart Collection.)

MUSICIAN. African Americans moved west as fur traders, mountain men, guides, miners, buffalo soldiers, pioneers, cowboys, farmers, musicians, entrepreneurs, doctors, lawyers, and business people. (Courtesy BAWM, Paul W. Stewart Collection.)

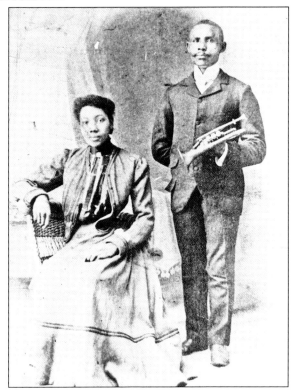

JULY 4, 1876. Cowboy Nat Love earned the title Deadwood Dick after winning a riding, roping, and shooting contest in Deadwood, South Dakota, on July 4, 1876. Love moved to Denver in 1890. One year later, he became a Pullman Porter for the Denver and Rio Grande Railroad. In 1907, Love published his autobiography, *The Life and Adventures of Nat Love*. (Courtesy BAWM, Paul W. Stewart Collection.)

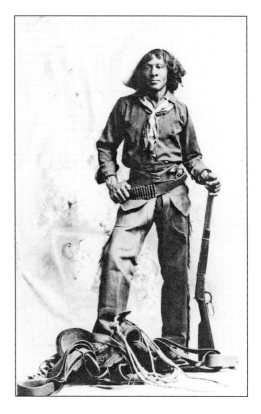

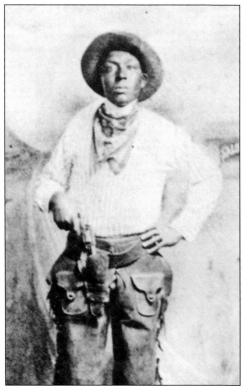

HOLLYWOOD HOP. James Arthur Walker was born in Terrell, Texas, in 1868. His friends nicknamed him "Cowboy" and said that Walker "would come riding into the yard at full speed, jump to the ground, then hop back upon his horse while the horse was still running." In later years, the trick became known as the Hollywood Hop and was made famous by Hollywood cowboy stars. (Courtesy BAWM, Paul W. Stewart Collection.)

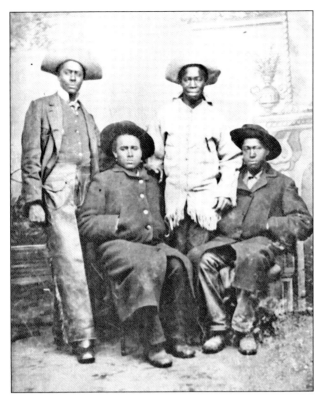

CHERRY CREEK. In the late 1880s, the Parker brothers owned a ranch in Cherry Creek. For African Americans, the cattle industry offered one of the few chances for equal careers. Thousands of African American cowhands drove cattle up the trails from 1865 until 1890, enabling them to purchase their own ranches and farms. (Courtesy BAWM, Paul W. Stewart Collection.)

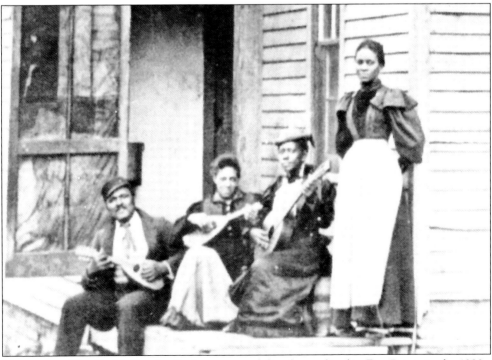

MANDOLIN. The Pie Mullins family, famous mandolin players, lived in Five Points in the 1880s. (Courtesy BAWM, Paul W. Stewart Collection.)

ONE HUNDRED BLACKS PETITION. Lewis H. Douglass (right) and Frederick Douglass Jr. (below), sons of abolitionist Frederick Douglass, served as sergeant majors in the Civil War and then migrated to Denver. The Douglass Undertaking Company, located at 2745 Welton Street, was known as "the Old Reliable." The Douglass brothers created the first black school in Denver and ran a restaurant on California Street. Both were signers of the 100 Blacks Petition, which was a petition for the right to vote. (Courtesy BAWM, Paul W. Stewart Collection.)

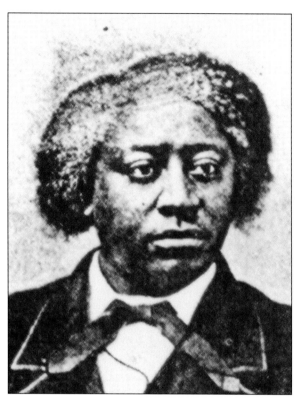

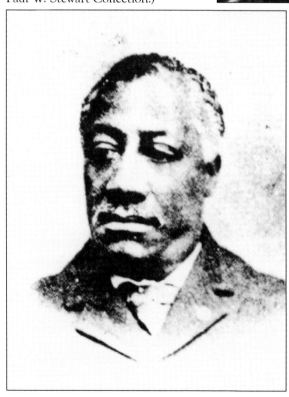

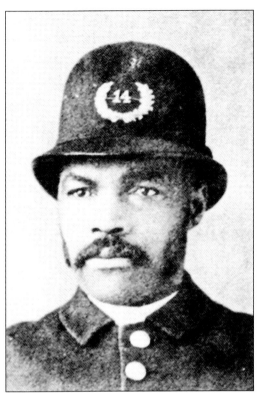

CIVIL WAR VETERAN. In the 1890s, Francis T. Bruce was listed on the Denver police roster as a policeman, and in 1892, he was appointed as a bailiff for Denver's Municipal Court. Bruce helped to organize the black Masonic Lodge and was known affectionately as "Daddy" Bruce to the community. (Courtesy BAWM, Paul W. Stewart Collection.)

CALIFORNIA GOLD RUSH. Edward J. Sanderlin left Tennessee as a young man and followed the California Gold Rush in 1849, becoming wealthy. Later he moved back East and lost his fortune while speculating. In 1859, Sanderlin moved to Denver when almost broke. Once established, he opened Denver's first barbershop and then a restaurant, rebuilding his wealth. As he invested in property, Sanderlin helped African Americans settle in the area and purchase new homes. (Courtesy BAWM, Paul W. Stewart Collection.)

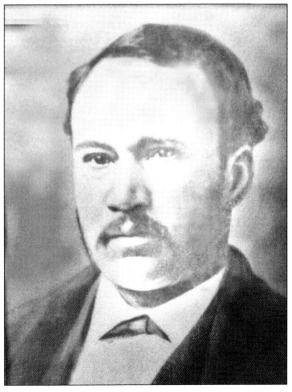

WILLIAM H. MORRISON, 1892. The eldest brother of acclaimed bandleader George Morrison, William H. Morrison played the piano in the family musical group that formed during their early years in Boulder. (Courtesy BAWM, Paul W. Stewart Collection.)

OXFORD MUSIC GROUP. Pictured here in 1892, William Morrison Sr. (fourth man from left with cane) brought his family to Colorado in the early 1880s. He was the father of George Morrison. (Courtesy BAWM, Paul W. Stewart Collection.)

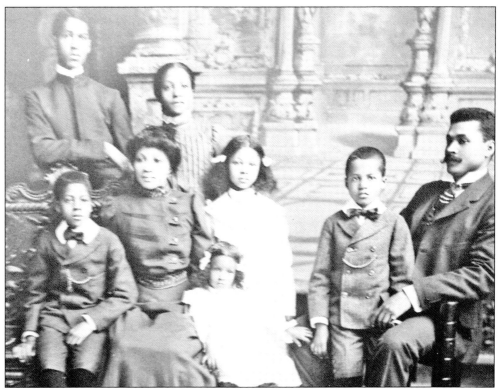

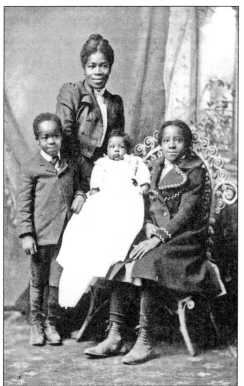

Denver Migrating Family. In the 1800s, the U.S. population moved west. Land, jobs, and the lure of gold and silver drew people of all races and backgrounds. For African Americans, the West offered freedom from persecution. Before the Civil War, western territories had no slavery and placed fewer restrictions on African Americans. In the post-war South, although slavery was outlawed, racial oppression was severe. Many joined the westward movement to escape it. (Courtesy BAWM, Paul W. Stewart Collection.)

Homesteaders. The Homestead Act, passed in 1862, gave western land to anyone who farmed it for five years. For former slaves with little money, this was a golden opportunity to acquire land and build an independent life. They came in wagon trains, built sod houses and log cabins, and worked at every occupation on the frontier, doing whatever they could to earn money. That usually meant a variety of jobs such as vegetable farming; raising goats, pigs, cows, and sheep; breaking horses; and herding cattle. (Courtesy BAWM, Paul W. Stewart Collection.)

PENNY FARTHING. Harry Seamon, a bicyclist and motorcyclist, operated a bicycle and motorcycle repair shop located on the 600 block of Twenty-sixth Street. He placed first in a bicycle race from Denver to Colorado Springs and rode from Denver to New York on a motorcycle. Seamon is pictured on a Penny Farthing in front of his repair shop in the 1920s. (Courtesy BAWM, Paul W. Stewart Collection.)

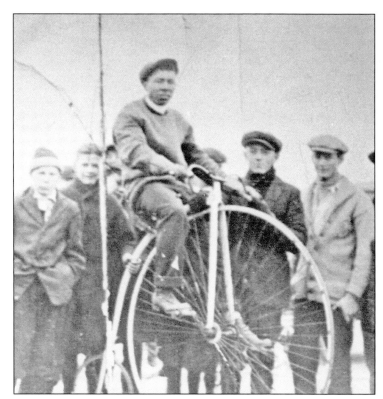

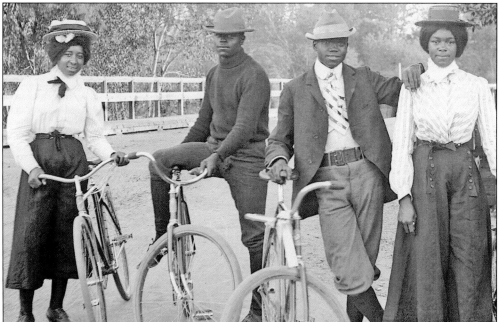

PARIS ON THE PLATTE. Mayor Robert Speer, with his City Beautiful plan, transformed Denver from a "dry dusty, treeless town on the high plains to Paris on the Platte." The plan changed the heart of the city into Civic Center Park and doubled Denver's green space. Two young couples are enjoying one of Denver's many new parks. (Courtesy Colorado Historical Society.)

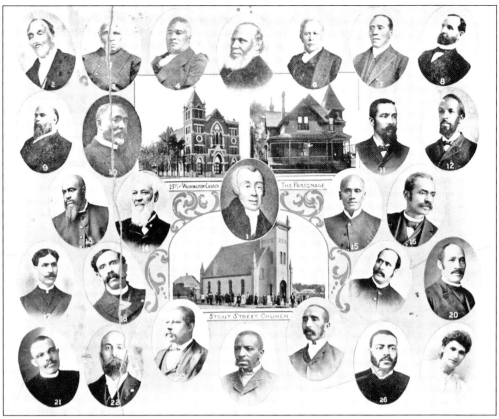

FOUNDING MEMBERS. The Shorter African Methodist Episcopal (AME) Church was situated in several locations in the late 19th and early 20th century. The Twenty-third and Washington Streets church and the Stout Street church, as well as the parsonage, are seen in this photograph celebrating the church's 47th anniversary. (Courtesy BAWM, Paul W. Stewart Collection.)

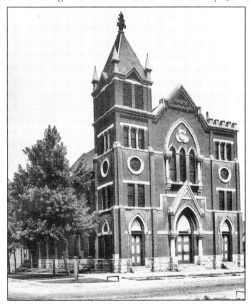

GOTHIC REVIVAL STYLE. The Shorter AME Church is one of the oldest African American churches in Denver. The original Shorter AME Church was located at Twenty-third and Washington Streets. The Gothic Revival–style building, constructed in 1888, was destroyed by a fire in 1925 that was allegedly started by the Ku Klux Klan. (Courtesy BAWM, Paul W. Stewart Collection.)

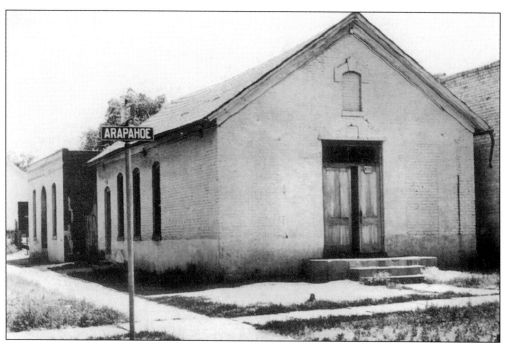

OLDEST BAPTIST CHURCH. The Zion Baptist Church is the oldest African American Baptist church in Colorado. The church was originally a log structure built by ex-slaves and was located at the corner of Twentieth and Arapahoe Streets in Five Points. (Courtesy BAWM, Paul W. Stewart Collection.)

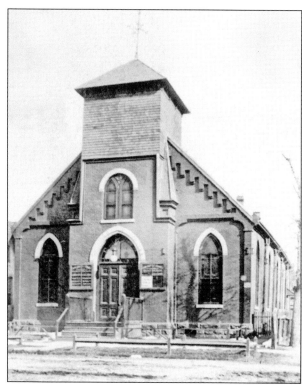

NEW LOCATION. In 1913, the Zion Baptist Church purchased Calvary Baptist's 1893 church building at 933 East Twenty-fourth Avenue. (Courtesy Gene Carter.)

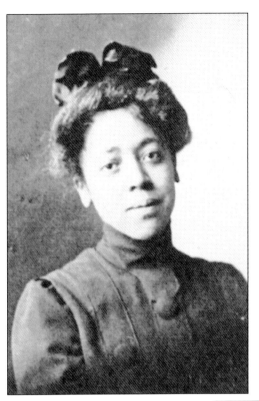

MEDICAL STUDENT. Justina Laurena Warren was born in 1871. On December 27, 1892, Warren married John L. Ford, who was 10 years older. The newlywed couple moved to Chicago, Illinois, where Justina enrolled as a medical student. In 1899, Ford graduated from Hering Medical College in Chicago and practiced in Normal, Alabama, for a short time. In 1902, the Fords moved to 1921 Curtis Street in Denver. (Courtesy Gene Carter.)

EUROPE. The husband of Dr. Justina L. Warren Ford was a minister at Zion Baptist Church. During his four years at Zion, the membership grew from 100 to 400. Rev. John Ford was vice president of the Golden Chest Mining, Milling, and Tunneling Company. In 1907, Ford went on a trip to Europe alone before relocating to Trinity Baptist Church in Jacksonville, Florida. In 1915, the Fords divorced. (Courtesy Gene Carter.)

Three
UP FROM SLAVERY

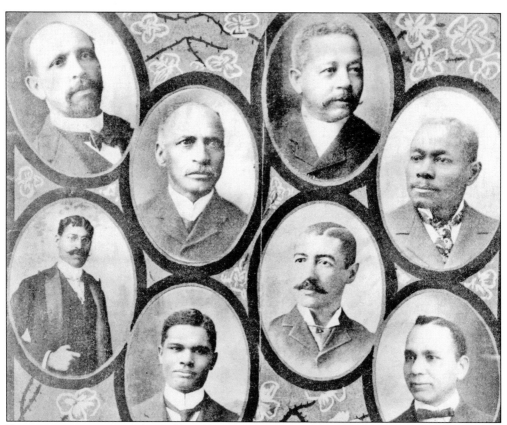

BOARD OF DIRECTORS. The Golden Chest Mining, Milling, and Tunnel Company was located at 1223 Nineteenth Street. Its board of directors included Dr. W. J. Cottrell, C. A. Franklin, Dr. P. E. Spratlin, J. W. Jackson, Rev. J. E. Ford, J. R. Lewis, G. C. Sample, and J. H. Stuart. (Courtesy BAWM, Paul W. Stewart Collection.)

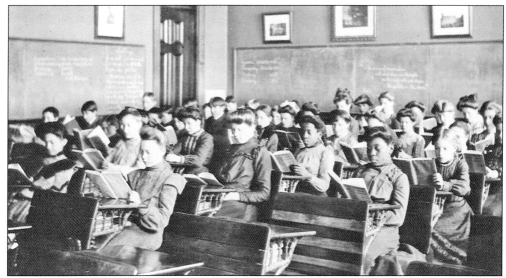

GILPIN SCHOOL. The Gilpin School was designed by Robert Roeschlaub in 1881 and was named after Colorado territorial governor William Gilpin. It was located at the corner of Twenty-ninth and Stout Streets. The original Gilpin School was torn down in 1951 when the new school was built on Thirtieth Street. This photograph was taken before the Great Migration of 1916–1919, a time when African Americans were leaving the South in large numbers to escape Jim Crow laws. By the early 1890s, more African Americans lived in Five Points than any other part of the city because of segregation. (Courtesy Colorado Historical Society.)

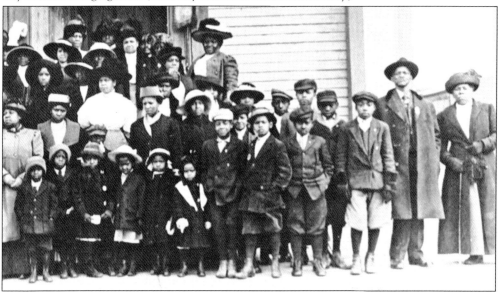

CENTRAL BAPTIST CHURCH. In 1891, a small group left Zion Baptist Church with the church's blessing under the leadership of W. P. T. Jones and formed Central Baptist Church. The congregation rented the Old Campbell AME Church at Twenty-third and Larimer Streets and purchased land at the corner of Twenty-fourth and California Streets. In 1912, excavation of the basement began, and by 1916, the cornerstone was laid. Improvements to the building continued throughout the 1920s, including the addition of an auditorium in 1925. (Courtesy BAWM, Paul W. Stewart Collection.)

FIELDS DEAR TO US. Born in 1862 in Ohio, Oliver Toussaint Jackson was inspired by Booker T. Washington's *Up From Slavery*. On May 5, 1910, Jackson established Dearfield. During the first winter in Dearfield, only two of the seven families had wooden houses, and the suffering was intense. Buffalo chips and sagebrush were their chief fuels. Three of the horses died from starvation, and the other three were too weak to pull an empty wagon. (Courtesy of the BAWM, Paul W. Stewart Collection.)

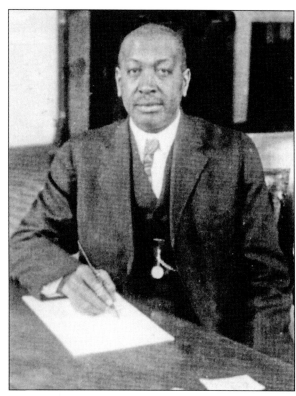

DEARFIELD COWBOY. James Dreayer was a cowboy who lived in Dearfield, a black agricultural colony on the arid high plains of Colorado. By 1915, Dearfield grew from seven families living in tents, dugouts, and caves in the hillside to 27 families residing in wooden cabins. The next five years would see the settlement grow to over 700 people. After World War I, demand for crops decreased, forcing families to sell or abandon homesteads. (Courtesy BAWM, Paul W. Stewart Collection.)

DEARFIELD PIONEER. Hattie Rothwell and her son Charles Rothwell moved from Denver to Dearfield in the spring of 1910. After two years of scraping a living on their homestead, Hattie moved back to Denver, leaving Charles to fend for himself. Charles began riding, breaking horses, and punching cattle for area cattlemen. (Courtesy BAWM, Paul W. Stewart Collection.)

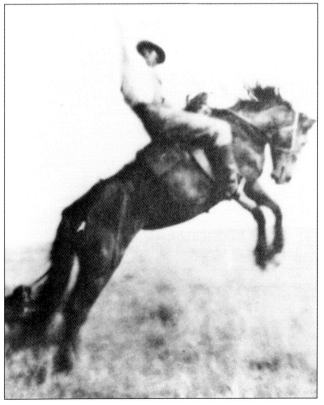

DEARFIELD RODEO. Charles W. Rothwell, born in Denver on September 12, 1895, resided at 1351 Jasmine Street. In the spring of 1910, his mother Hattie Rothwell borrowed $500 and moved the family to Dearfield. There they raised hogs, chickens, cows, watermelons, corn, and cucumbers, selling the cucumbers to the Kuner Pickle Company. Hattie returned to Denver in 1912. (Courtesy BAWM, Paul W. Stewart Collection.)

Four

FIELDS DEAR TO US

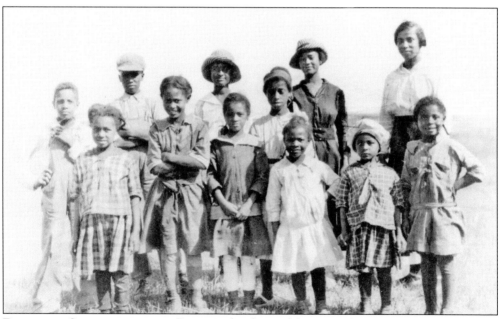

DEARFIELD SCHOOLCHILDREN. By 1918, the demand for crops dropped, and families began to default on their mortgages and equipment loans. In 1940, Dearfield's population dwindled to 12 people. Minerva Jackson, the wife of Oliver Toussaint Jackson, passed away in 1942. Six years later, on February 8, 1948, Oliver Toussaint Jackson died in Denver. The last Dearfield resident was Jackson's niece, Jenny Jackson, until her death in the early 1970s. (Courtesy BAWM, Paul W. Stewart Collection.)

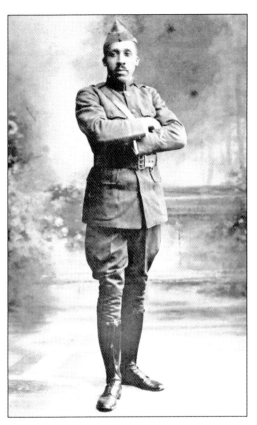

NEGRO OFFICERS SCHOOL. Earl Mann was one of the first men commissioned from the Negro Officers School, and he served in France during World War I. Mann was also a Colorado State Representative for five terms and helped to bring equal rights to African Americans. (Courtesy BAWM, Paul W. Stewart Collection.)

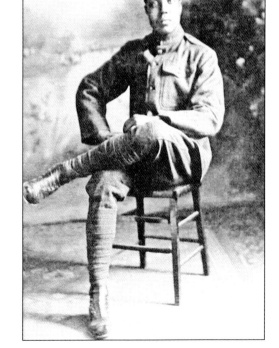

EMMA BAKER'S SON. Written on the back of the photograph is "Emma Baker's Son 1918." He was a Denver World War I veteran. (Courtesy BAWM, Paul W. Stewart Collection.)

PANTAGES CIRCUIT. John Morris was a dancer on the famous Pantages Circuit. Morris was also connected to the world of black entertainment through his brother Theodore Morris, who played with George Morrison. (Courtesy BAWM, Paul W. Stewart Collection.)

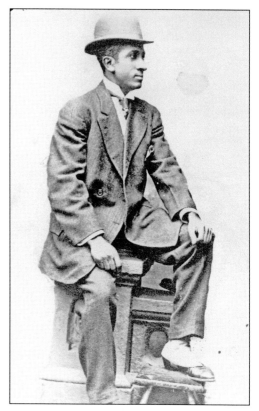

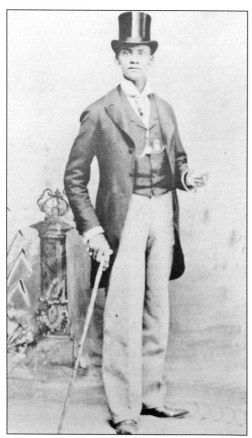

WILLIAM H. MORRISON, 1898. Eldest brother of George Morrison, Will Morrison played the piano. (Courtesy BAWM, Paul W. Stewart Collection.)

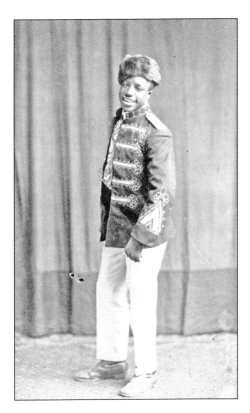

GLENWOOD SPRINGS. Walter Pride, seen here in 1915, was the first African American child born in Glenwood Springs. Pride danced and played with various groups before joining George Morrison's band as a drummer. When Morrison's band was invited to New York to record, its members were required to be multi-talented, so Pride could not go because he could only play one instrument. (Courtesy BAWM, Paul W. Stewart Collection.)

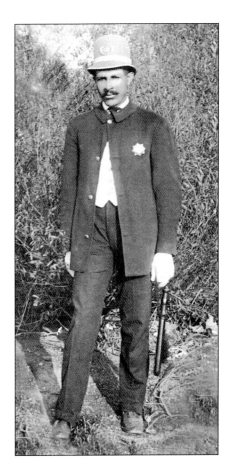

OFFICER WILLIAM BAKER. Among the first African American police officers in Denver were William Baker and his brother Ulysses Baker. (Courtesy BAWM, Paul W. Stewart Collection.)

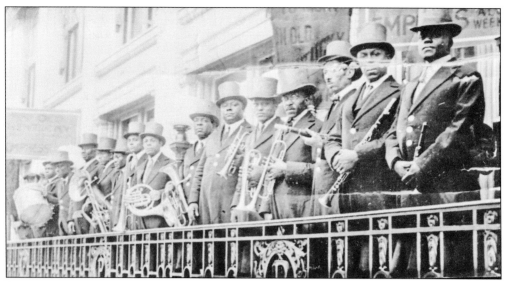

STRUTTIN' SAM MINSTRELS. The band is preparing to perform on the balcony of the Empress Theater on Curtis Street in downtown Denver. (Courtesy BAWM, Paul W. Stewart Collection.)

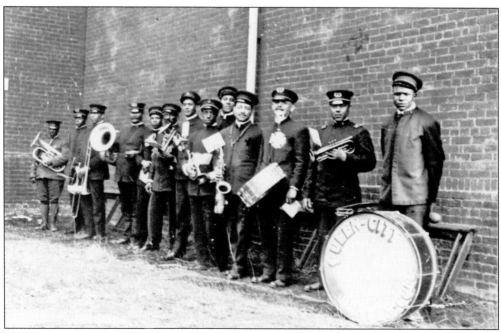

EARLY JAZZ BAND. The Queen City Band was one of the country's first jazz bands. This photograph was taken in 1913. (Courtesy BAWM, Paul W. Stewart Collection.)

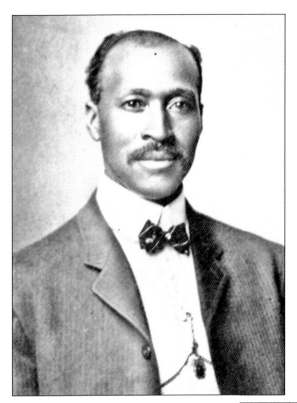

"TAKE YOUR CHOICE." Ben Boyer was a guard at the Salida prison and later a deputy sheriff in Canon City. He served as deputy sheriff in Salida from 1905 to 1915. After cornering a suspect, Boyer would say, "I'm going to take you in either standing or feet first. Take your choice." (Courtesy BAWM, Paul W. Stewart Collection.)

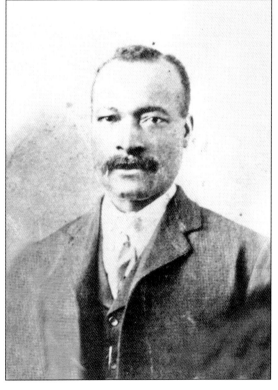

MANGANESE MINE. Bill Boyer managed a lime kiln and manganese mine in Wellsville, Colorado, and owned cattle. William Boyer, the father of Beatrice, Hattie, Bill, Ben, and James Boyer, was a farmer, blacksmith, and miner who came to Colorado in a covered wagon. The Boyers lived in Denver for a couple of years before moving to Coaldale. (Courtesy BAWM, Paul W. Stewart Collection.)

COWGIRL. Beatrice Boyer was a socialite and cowgirl. Boyer enjoyed living in Coaldale, where she learned to ride, rope, brand, and break horses. The family owned a large herd of cattle and horses, which all had to be branded, since cattle rustling and horse thievery were common. (Courtesy BAWM, Paul W. Stewart Collection.)

BIRTH OF A NATION. The first president of the Denver chapter of the National Association for the Advancement of Colored People (NAACP) was George W. Gross. Clarence Holmes, D.D.S., the *Denver Star* publisher and attorney George Ross founded the NAACP in 1915. Their first call to action was to lead protesters against the pro–KKK film *The Birth of a Nation* in Denver movie theaters. In 1925, the NAACP held their National Convention in Denver. (Courtesy BAWM, Paul W. Stewart Collection.)

ROCKY MOUNTAIN ARSENAL. Shelby Adams purchased 75 acres located at 9600 East Belleview Avenue in Littleton shortly after the Works Project Administration (WPA) first began developing the Cherry Creek Dam in 1936. Adams donated land to the government, which is now part of the Rocky Mountain Arsenal. He owned the Adams Home Bakery in Five Points, the only African American bakery in Colorado, until his retirement. (Courtesy BAWM, Paul W. Stewart Collection.)

Five
Town Hall of Five Points

DENVER POST. Paul Laurence Dunbar was born in Dayton, Ohio, in 1872. After being diagnosed with tuberculosis, he accepted a writing contract with the *Denver Post*. Dunbar arrived in Denver on September 12, 1899. Dunbar was the first African American poet to garner national critical acclaim. His work often addressed the difficulties encountered by members of his race and the efforts of African Americans to achieve equality in America. Dunbar penned dialect poems, standard English poems, essays, novels, and short stories before he died at the age of 33. (Courtesy BAWM, Paul W. Stewart Collection.)

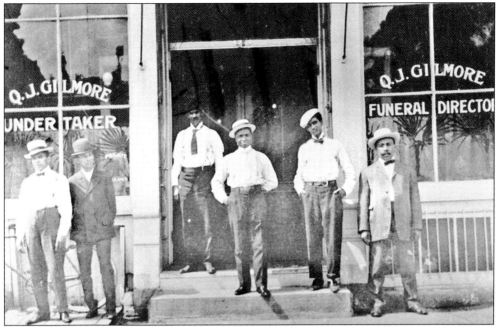

ARAPAHOE STREET. Quinn J. Gilmore was a Five Points African American undertaker and funeral director. This photograph was taken in 1908 with the employees standing in front of the business establishment located at 1921 Arapahoe Street. (Courtesy BAWM, Paul W. Stewart Collection.)

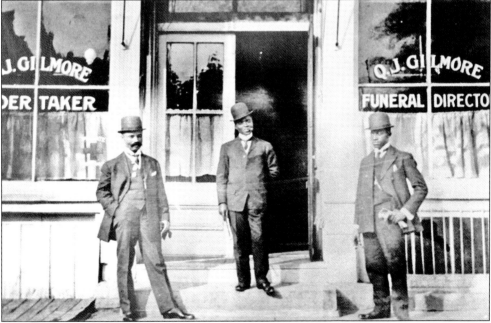

QUINN J. GILMORE. Gilmore's undertaking business started in 1908 and was located at 1921 Arapahoe Street. Gilmore started at a time when there were very few African American undertakers. Pictured here from left to right in front of the business are unidentified, Driddy Gilmore, and Quinn J. Gilmore. (Courtesy BAWM, Paul W. Stewart Collection.)

YWCA. The Phyllis Wheatley Colored YWCA was located at 2460 Welton Street. For almost 50 years, the branch operated a residence hall; a summer mountain camp called Camp Nizhoni located in the Lincoln Hills; programs such as Business Girls Club, Industrial Girls Clubs, and Girls Reserves; an employment bureau; and art and recreation classes. In 1964, it was the last official segregated YWCA to close its doors. (Courtesy BAWM, Paul W. Stewart Collection.)

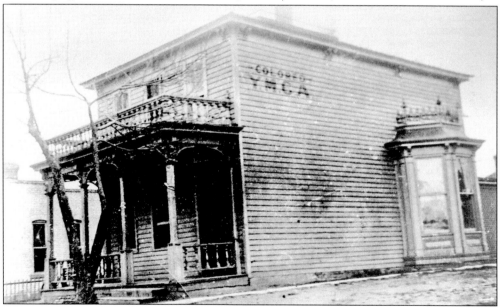

YMCA. The YMCA was known as the town hall of Five Points because it was the center of activity for nearly 6,000 African American residents. Doctors, lawyers, dentists, clergy, railroad porters, and service workers made their homes in Five Points, attending its many churches, patronizing black businesses, supporting three newspapers, and enjoying the YMCA, the YWCA, baseball clubs, and social activities of all kinds. (Courtesy BAWM, Paul W. Stewart Collection.)

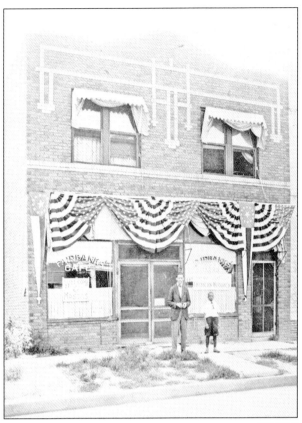

WELCOME. The Fairbanks Hotel and Café was located at Twenty-sixth and Welton Streets in 1926. Notice the signs in the window—Welcome Masons and Welcome American Woodmen. (Courtesy BAWM, Paul W. Stewart Collection.)

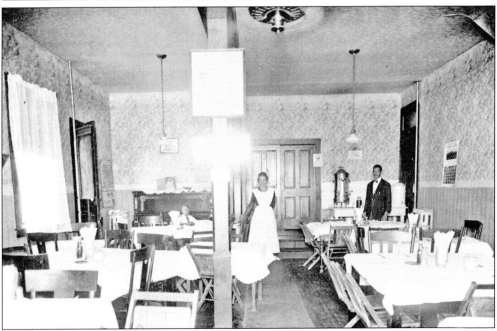

FAIRBANKS CAFÉ, 1925. Standing inside of the Fairbanks Café is owner Nora Gibson Fairbanks and an unidentified man. (Courtesy BAWM, Paul W. Stewart Collection.)

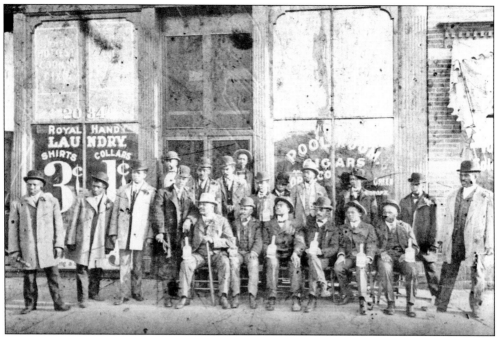

LARIMER STREET. Tal Green's billiard parlor was located at 2034 Larimer Street. The bottles of alcohol were added after photographer William Cain took the image in 1903. (Courtesy BAWM, Paul W. Stewart Collection.)

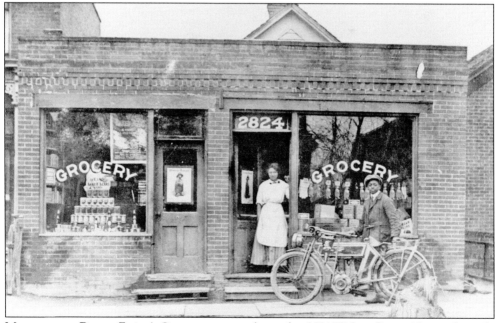

MOTORCYCLE RIDER. Ewing's Grocery store was located at 2824 Welton Street. Notice the early motorcycle on the right of the photograph. (Courtesy BAWM, Paul W. Stewart Collection.)

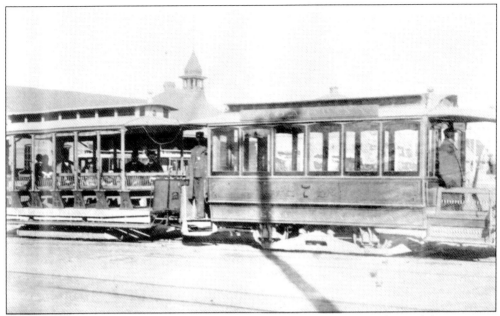

THE DENVER HORSE RAILROAD COMPANY. Because the signs on the front of the streetcars traveling to the Curtis Park area were not big enough to hold all of the street names that converged at Twenty-seventh Street, Washington Street, East Twenty-sixth Avenue, and Welton Street, the area was quickly dubbed "Five Points." (Courtesy BAWM, Paul W. Stewart Collection.)

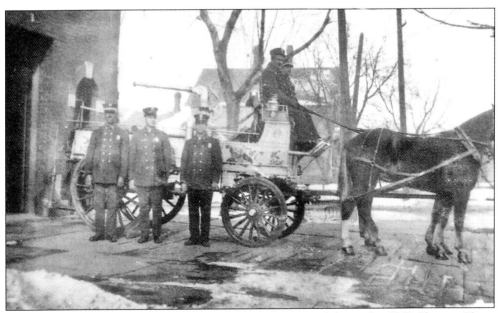

FIRST AFRICAN AMERICAN FIRE COMPANY. Fire Station No. 3, located at 2563 Glenarm Place, was the first African American fire company. This photograph, taken in 1907, shows Captain Biffle standing third from the left with his fellow firemen and their horse-drawn fire engine. Built by the city in 1888 to accommodate the growing suburbs, it became an all African American company in 1893. The Wallace Simpson American Legion Post now occupies the fire station. (Courtesy BAWM, Paul W. Stewart Collection.)

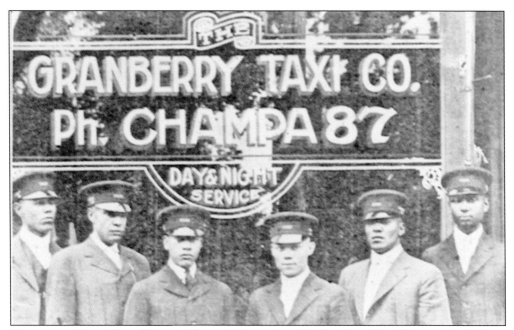

GRANBERRY TAXI. One of Denver's first taxicab services, the Granberry Taxi Company's telephone number was CHAMPA 87. Dr. Justina L. Ford made house calls to her patients and was a regular customer. (Courtesy BAWM, Paul W. Stewart Collection.)

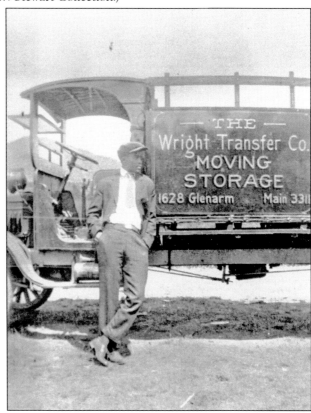

EARLY MOVING COMPANY. The Wright Transfer Company was located at 1628 Glenarm, and its telephone number was Main 3311. (Courtesy BAWM, Paul W. Stewart Collection.)

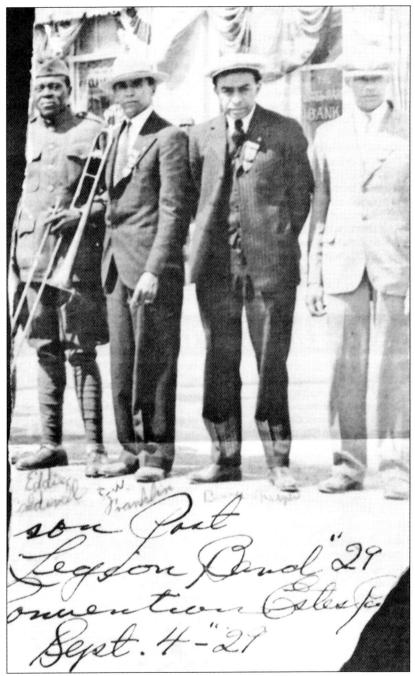

MAYOR OF FIVE POINTS. Pictured from left to right are Eddie Caldwell, C. W. Franklin, Benny Hooper, and unidentified. Benny Hooper owned the Ex-Service Men's Club located at 2626 Welton Street. After World War I, African American soldiers found that they were still discriminated against in places such as restaurants, clubs, and hotels, so Hooper decided to open his own club, which included a ballroom, pool hall, recreation center, and hotel. Hooper was also known for his charitable activities. During the Depression, he distributed food to the needy by making rabbit stew. The meat was donated by area sportsmen. (Courtesy BAWM, Paul W. Stewart Collection.)

WILLIAM BAKER. This photograph and an article appeared on Tuesday, February 24, 1921, in the *Times Daily Roll Honoree*. Part of the article stated, "Patrolman William Baker won official commendation for aiding in capture of Forrest Johnson, Negro Bandit." (Courtesy BAWM, Paul W. Stewart Collection.)

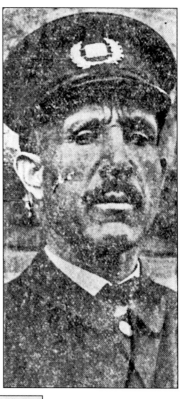

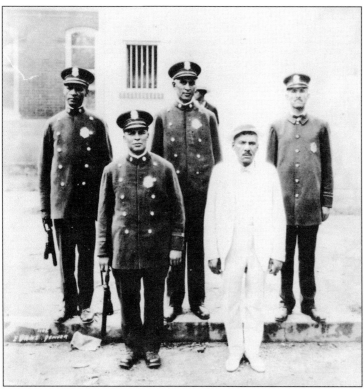

BAKER BROTHERS. Pictured from left to right are (first row) unidentified and Ulysses Baker; (second row) two unidentified and William Baker. William was appointed under-sheriff of Denver. He was later promoted to police officer. Ulysses was Denver's first African American detective on the police force. He also served as a bodyguard to Mayor Benjamin Stapleton and created the Auto Theft Department; it was the first of its kind in the West. (Courtesy BAWM, Paul W. Stewart Collection.)

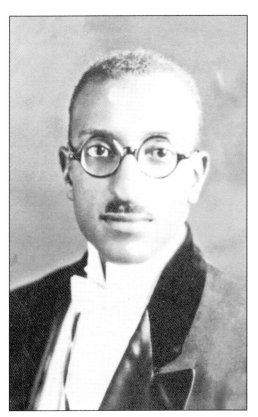

DENVER NAACP FOUNDER. Clarence Holmes came to Denver as a child in 1890. He attended Ebert Elementary School, graduated from Manual Training High School, entered Howard University to study dentistry, and passed the Colorado Dental Board Exams in 1920. Dr. Holmes was an active civic leader and one of the founders of the Denver chapter of the NAACP. (Courtesy BAWM, Paul W. Stewart Collection.)

MAJ. THOMAS CAMPBELL (1869–1957), ATTORNEY. At age 24, Campbell graduated from Howard Law School. Joining the military, he achieved the rank of major and led troops in Cuba and the Philippines during the Spanish-American War. Campbell came to Denver in 1904 and founded the *Denver Independent*, a black newspaper. He also founded the Denver Urban League in 1919. (Courtesy Lula Jacobs.)

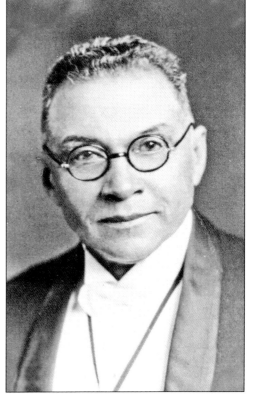

Six

BROTHERS AS GOD INTENDED

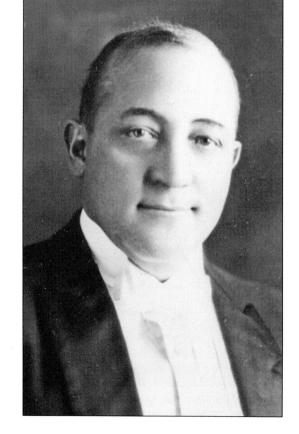

UNDERCOVER. Dr. Joseph Henry Peter Westbrook named the colony Dearfield because "the fields are dear to us." He was a physician and drugstore owner. Westbrook was also a member of Zion Baptist Church, the Masons, Boule, and the Mountain Lodge of Elks No. 39 of Denver. Westbrook passed as a white man to infiltrate the KKK and alerted the African American community to its plans. (Courtesy BAWM, Paul W. Stewart Collection.)

COLORADO'S FIRST AFRICAN AMERICAN LICENSED DENTIST. Dr. Thomas Ernest McClain was Colorado's first African American licensed dentist. In 1907, after attending dental school at Meharry Medical College at Walden University in Nashville, Tennessee, he moved to Denver with his wife, Lafayette L. Stewart McClain. In 1909, their twin daughters, Josephine Bell and Ernestine Lillian, were born. Dr. McClain was a member of Zion Baptist Church, Boule, the Masons, and the Mountain Lodge of Elks No. 39 of Denver. Dr. Joseph Henry Peter Westbrook and Dr. McClain were best friends. (Courtesy Terri Lynne Smith Gentry.)

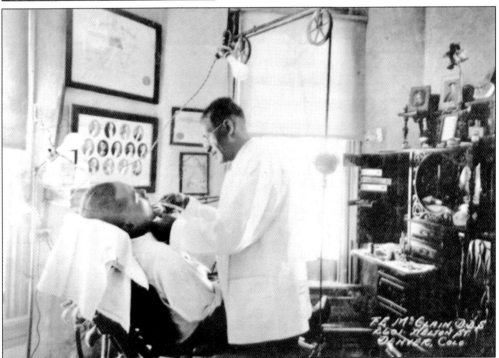

MCCLAIN DENTISTRY. For over 40 years, Dr. Thomas Ernest McClain provided quality dental care to patients of all economic and ethnic backgrounds. (Courtesy Terri Lynne Smith Gentry.)

"WONDERFUL HAIR GROWER." Sarah Breedlove moved to Denver in 1905 as a sales woman for St. Louis businesswoman Annie Pope-Turnbo. She also married her third husband, newspaper sales agent Charles Joseph Walker. Walker opened a parlor at 2317 Lawrence Street, manufacturing and marketing products such as "Wonderful Hair Grower." After her divorce in 1910, she moved to Indianapolis, offering her products for sale through door-to-door agents called Madam C. J. Walker Hair Culturists. (Courtesy BAWM, Paul W. Stewart Collection.)

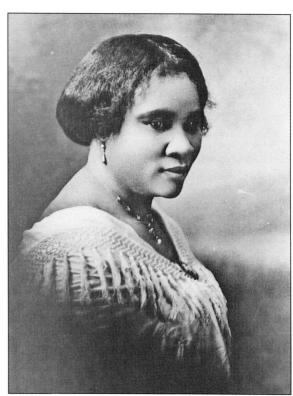

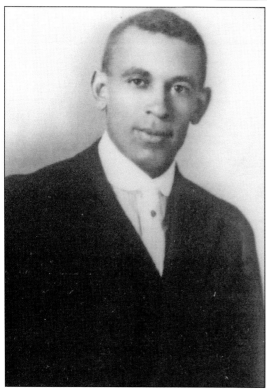

AFRICAN AMERICAN ATTORNEY. On July 9, 1886, Samuel Eddy Cary was born in Providence, Kentucky. After graduating from law school, Cary, his wife, and their two children moved to Denver in 1919, and Cary was admitted to the Colorado Bar Association, specializing in criminal law. In 1926, the Colorado Bar Association disbarred Cary on the grounds of "neglect and dereliction of duty in representation of his clients." Cary's license was reinstated in 1935 after it was proved that the accusations had been false in order to discredit him. In 1971, the Samuel Cary Bar Association, a black law association, was established. (Courtesy Blair Caldwell African American Research Library, Cary Family Collection.)

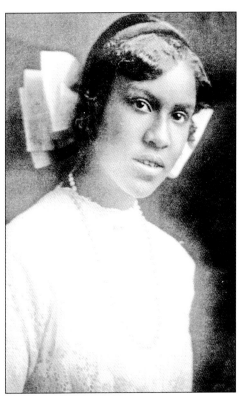

SARAH GERTRUDE RUSSELL FOUNTAIN. Sarah Gertrude Russell Fountain was born on October 25, 1900. Fountain graduated from the commercial department at Manual Training High in June 1919. She passed the Colorado State Teachers examination, earning a second-grade certificate. When a vacancy became available in Wiggins, Colorado, at the Dearfield School, Fountain took it and taught there from January 1919 until June 1921. Her salary was $70 per month with a bonus of $90 at the close of the term. (Courtesy BAWM, Paul W. Stewart Collection.)

WILLIAM DANIELS FOUNTAIN. William Fountain was born in Denver, Colorado, on January 9, 1898. He graduated from North High School in June 1917. Fountain earned a degree in veterinary medicine from Colorado State Agriculture College, now known as Colorado State College, in June 1926. Fountain was appointed as a veterinarian for the Bureau of Animal Industry for the U.S. Department of Agriculture (USDA) in Omaha, Nebraska. In 1926, as veterinary meat inspector and eventually the supervisor of veterinarians at the Denver stockyards, Fountain worked in the consumer and marketing division for the USDA. (Courtesy BAWM, Paul W. Stewart Collection.)

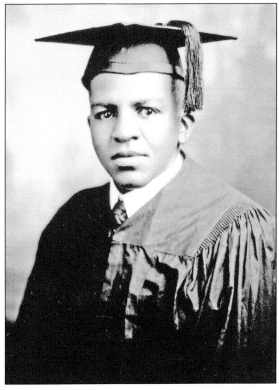

CHEYENNE CANYON. Marcus Garvey arrived in Colorado Springs on May 23, 1922. After leaving Colorado Springs, he traveled to Denver, where he delivered two addresses on behalf of the Denver Division. Shown in the photograph are Marcus and Amy Jacques Garvey (then Garvey's personal secretary) in Colorado Springs, sightseeing in Cheyenne Canyon. The two were married in Baltimore, Maryland, on July 22, 1922. (Courtesy Paul Stewart.)

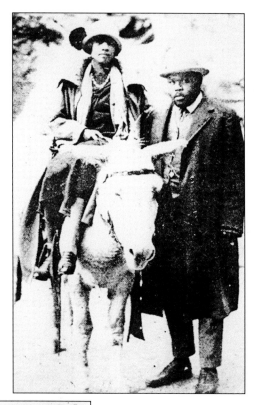

LOOK WHO IS COMING

Hon. Marcus Garvey

Provisional President of Africa, and President General of the Universal Negro Improvement Association

He Will Speak at Fern Hall Sunday Oct. 5---3 p. m. and 8 p. m.

Admission 50c Cents

FERN HALL. When the Garveys toured Colorado in 1924, they spoke before two Colorado divisions of the Universal Negro Improvement Association. Garvey spoke in Denver at Fern Hall on October 5, 1924. An advertisement appearing in the *Colorado Statesman* read: "Look Who is Coming to Denver." Amy Jacques Garvey spoke in Colorado Springs during its division meeting at People's Methodist Episcopal Church on the evening of October 13, 1924. (Courtesy *Colorado Statesman.*)

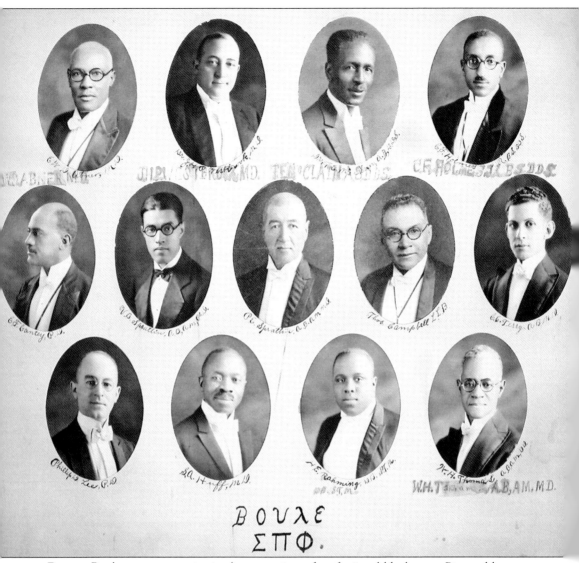

BOULE. Boule was an organization/secret society of professional black men. Pictured here are, from left to right, (first row) E. W. D. Abner; J. H. P. Westbrook; T. E. McClain; and C. F Holmes; (second row) E. F. Canty, Ph.D.; V. B. Spraitlin; P. E. Spraitlin; Thomas Campball; and C. E. Terry; (third row) Phillip D. Lee, Ph.D.; S. A Huff, M.D.; H. E. Rahming; and W. H. Thomas. (Courtesy Terri Lynne Smith Gentry.)

GEORGE MORRISON. Born in Fayette, Missouri, on September 9, 1891, George Morrison came from a musical family and at an early age made a violin from a corn stalk, a piece of wood, and some string. In 1900, the family moved to Boulder, Colorado. Morrison and his brother entertained mining camps west of Boulder. (Courtesy BAWM, Paul W. Stewart Collection.)

MORRISON BAND. In 1911, Morrison formed his band, George Morrison and his Jazz Orchestra, one of Denver's first jazz orchestras. (Courtesy BAWM, Paul W. Stewart Collection.)

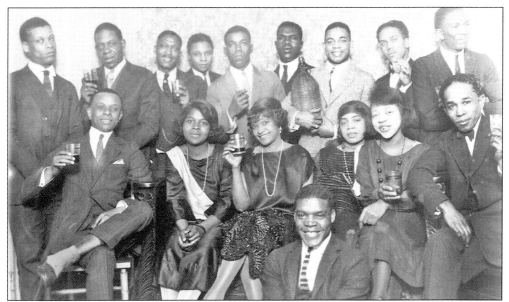

MORRISON'S 11-PIECE BAND. In 1920, Columbia Records invited George Morrison and his band to New York, where they recorded under the name Morrison's Singing Jazz Orchestra. The band also traveled to London for a command performance for King George and Queen Mary. Morrison signed with the Pantages Circuit, a booking agency. In 1924, Hattie McDaniel joined the band. Morrison taught violin to neighborhood children, was the violinist for Shorter AME Church, and founded the black Musicians Local No. 623. (Courtesy BAWM, Paul W. Stewart Collection.)

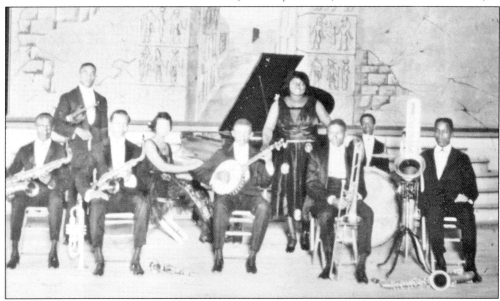

ACADEMY AWARD. Hattie McDaniel lived in Denver, attended East High School, and toured with her family's traveling Baptist tent show. In the 1920s, she joined George Morrison's orchestra, touring the Pantages and Orpheum vaudeville circuits. McDaniel performed with the Melony Hounds on Denver's radio station KOA and was the first African American to win an Academy Award, in 1939, for best supporting actress for her portrayal of Mammy in *Gone with the Wind*. (Courtesy BAWM, Paul W. Stewart Collection.)

JAZZY TOE TWINS. When Ernestine and Josephine McClain were 12 years old, George Morrison invited Bill "Bojangles" Robinson to the McClain home. Robinson watched the twins dance and invited them to New York City. Two years later, the twins were part of the stage production *Black Birds of 1931*. The McClain twins perfected jazz dancing on point and were known as the Jazzy Toe Twins. (Courtesy Terri Lynne Smith Gentry.)

ERNESTINE MCCLAIN. After the untimely death of Josephine McClain, Ernestine McClain retired from show business and returned to Denver, where she taught private dance lessons. In 1944, she was hired by the Denver Department of Parks and Recreation as a recreation specialist teaching different dance forms and charm classes. In 1951, she began the Ajose Dancers, the first African dance troop in Denver. (Courtesy Terri Lynne Smith Gentry.)

TOP HAT. This photograph of young Walter Marshall shows him dressed in a top hat and tuxedo. The Marshall Brothers, under the supervision of their father, Orea Marshall Sr., played for local church groups and social functions early in their careers. (Courtesy BAWM, Paul W. Stewart Collection.)

YOUNG TRIO. At age six, Walter Marshall played in a combo with his brothers Orea (age 12) on piano, and Harry (age nine) on violin. Orea and Harry Marshall wrote and acted in their own plays, and performed with George Morrison's band. (Courtesy BAWM, Paul W. Stewart Collection.)

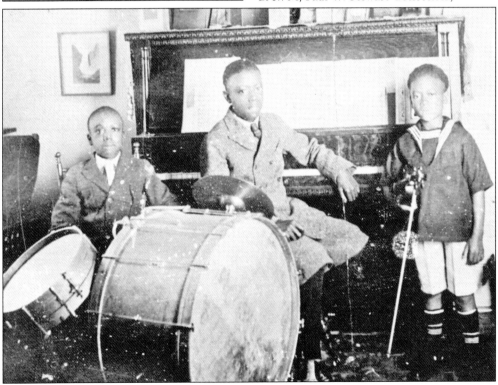

DESDEMONA WEAVER DAVIS, 1924. Born in Evergreen Colorado, Desdemona Weaver was one of 19 children. She played the piano in an orchestra in 1924–1925. She married Leo Davis, a member of George Morrison's band, and also played in her husband's band. (Courtesy BAWM, Paul W. Stewart Collection.)

MARY LOU WILLIAMS AND OTHEOLA HARRINGTON, 1933. Mary Lou Williams (right) was a pianist and composer. She wrote two hit songs, "Christopher Columbus" and "Little Joe from Chicago." Otheola Harrington (left) is the wife of saxophonist John Harrington, a musician who played with Andy Kirk. (Courtesy BAWM, Paul W. Stewart Collection.)

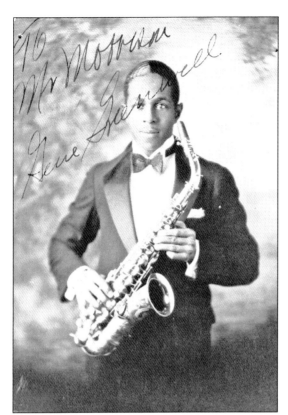

GENE GREENWELL. Greenwell was a saxophonist and one of the many musicians who played with George Morrison's band. The autograph on the photograph reads, "To Mr. Morrison, Gene Greenwell." (Courtesy BAWM, Paul W. Stewart Collection.)

SWINGIN' SWANKIES. While still in their early teens, one of Denver's popular musical groups began studying music and playing together. Pictured from left to right are John Whitney, piano; Arthur Tidmore, drums; Roy Anderson, guitar; Joe Gayles, tenor sax; Adam "Coot" Berry, trombone; unidentified; Bill Graham, saxophone; Paul Quinichette, trumpet; and unidentified. (Courtesy BAWM, Paul W. Stewart Collection.)

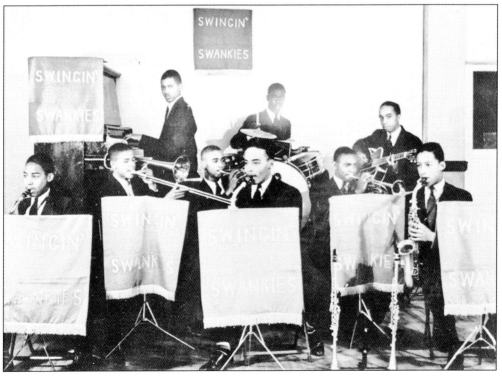

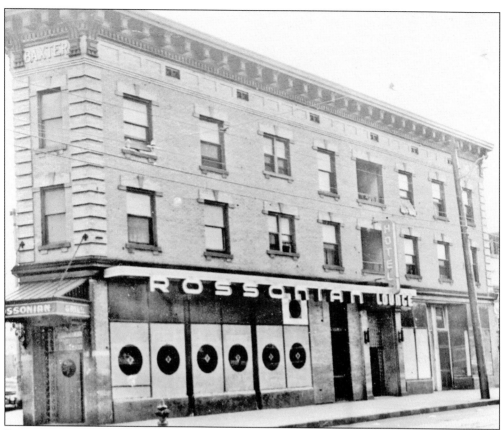

ROSSONIAN HOTEL AND LOUNGE. Located at Twenty-seventh and Welton Streets at the five-way intersection that is Five Points' namesake, the Rossonian was formerly known as the Baxter Hotel until H. W. Ross purchased it and changed its name in 1929. (Courtesy BAWM, Paul W. Stewart Collection.)

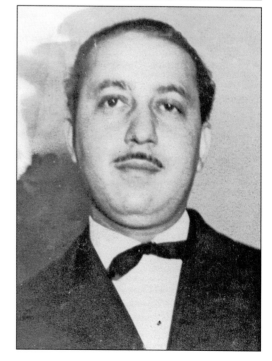

QUENTIN HARRINGTON. Quentin Harrington and John Kigh operated the Rossonian Hotel and Lounge. The Rossonian was one of the most popular entertainment centers in Denver. The top black jazz musicians and entertainers appeared there during the 1940s and 1950s. (Courtesy BAWM, Paul W. Stewart Collection.)

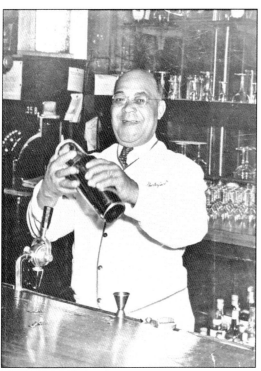

ROSSONIAN BARTENDER, C. 1935. Charlie Parker, Duke Ellington, Billie Holiday, and Nat King Cole once played at the Rossonian Hotel and Lounge's jazz club. The Rossonian was known throughout the country for its excellent service and music. (Courtesy BAWM, Paul W. Stewart Collection.)

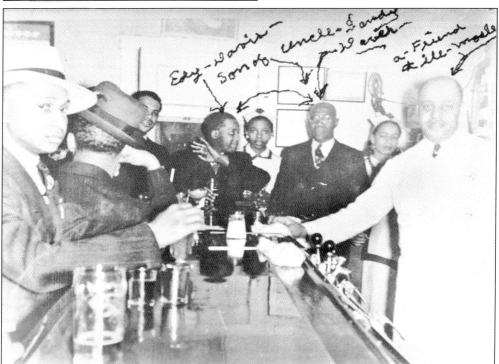

ROSSONIAN CLUB LUNCH. This was known as a "Rossonian Club Lunch." Pictured from left to right are Oliver Seymour, two unidentified, Eddie Davis (son of Sandy Davis), Pauline Holliday, Sandy Davis, Bill Kigh's sister, and the bartender. (Courtesy BAWM, Paul W. Stewart Collection.)

SITTING PRETTY. As a teenager, Esther Mae Barnett, a talented singer and pianist, began traveling throughout the United States with the jazz group known as the Harmony Singers. (Courtesy Maxine Parks.)

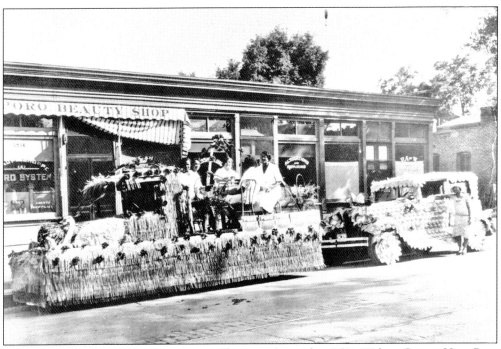

PARADING BEAUTIES. The Poro Beauty Shop was located at 2554 Welton Street. Here Poro Beauty Shop hairdressers are sitting comfortably on top of their beautifully decorated float. Jenny Britton Bradshaw, owner and operator of the shop, is standing beside her decorated automobile in a brim hat and flapper dress. (Courtesy BAWM, Paul W. Stewart Collection.)

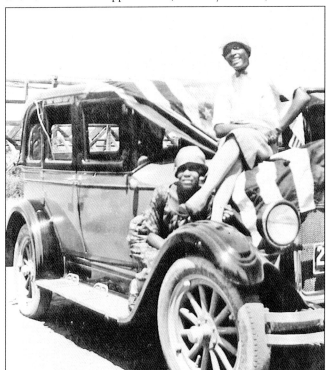

FLAG-COVERED CAR. On the Fourth of July, Maxine Alice Satterwhite (on the running board) and her mother, Ester Mae (sitting on the hood), traveled from La Junta to Rocky Ford to enjoy the celebrations. (Courtesy Maxine Parks)

STRAW HAT. Maxine Alice Satterwhite was born on March 28, 1922, in La Junta, Colorado. Like many early pioneers, she lived in another part of the state before settling in Denver. Maxine, age 8, stands in front of her home in La Junta. As a young girl, she listened to Lulu Sadler Craig, who told her many childhood stories of Nicodemus, Kansas, an all-black pioneer town. (Courtesy Maxine Parks.)

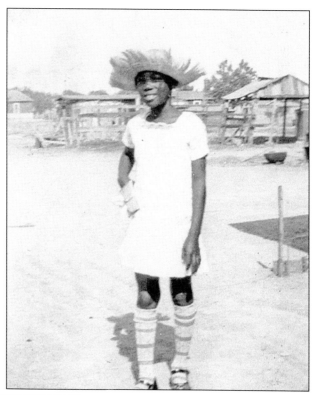

MCVEY FAMILY. Pictured from left to right are (first row) Kenneth, Hazel, and Helen McVey; (second row) Genevieve McVey. (Courtesy BAWM, Paul W. Stewart Collection.)

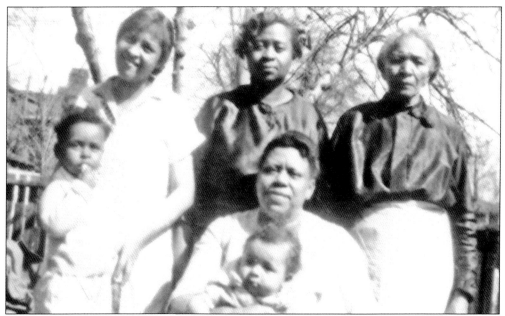

FIVE GENERATIONS. Pictured in Denver, Colorado, in 1930 are five generations of Harriette Bailey's descendants. From left to right are (seated) Anna McPherson holding Frank Davis McLuster; (standing) William James McLuster Jr., Goldie McLuster, Callie Kromwell, and Harriette Bailey. Frank and Anna McPherson moved to Denver with their daughter Callie in 1903. (Courtesy Terri Lynne Smith Gentry.)

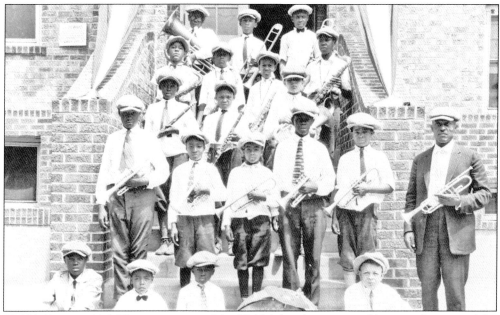

YMCA BAND, 1926. The young men of the YMCA band are pictured here on the steps of the new YMCA building, completed in 1925. Eddie Rucker directed the band. Identified band members are: James Richardson, tuba; Stanley Bently, trombone; Billy Gross Sr.; Ken Dillard; Hubert Jones; Paul Anthony; James Gaskins; Harry Stevenson; Bill Graham; and Chaucer Spikner. (Courtesy BAWM, Paul W. Stewart Collection.)

THE GLENARM BRANCH OF THE YMCA. The Fourth Annual Membership Campaign at the Glenarm branch of the YMCA in Denver, Colorado, was held from October 7 to 17, 1930. The goal was to reach a membership of 500. The Glenarm branch was known as the "town hall" of Five Points because it served as the center of cultural and social life in the African American community. (Courtesy Blair Caldwell African American Research Library.)

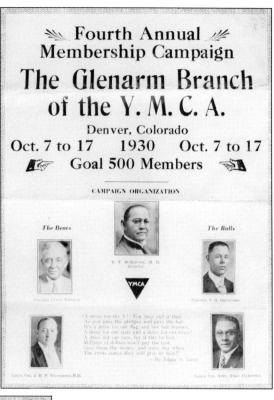

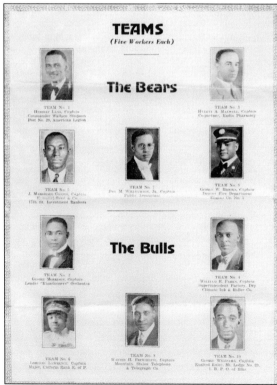

THE FOURTH ANNUAL MEMBERSHIP CAMPAIGN. At the Glenarm branch of the YMCA, the director of the annual campaign was T. T. McKinney. This campaign was made of two teams: the Bears and the Bulls. The Bears team, led by Clint Thomas, were J. H. P. Westbrook, Herbert Lane, ? Hulett, ? Maxwell, J. Marshall Coates, J. M. Williamson, and George Brooks. The Bulls team consisted of T. G. Grandberry, Thomas Campbell, George Morrison, William Parks, Lorenzo Lawrence, Walter Pritchette, and George Williams. (Courtesy Blair Caldwell African American Research Library.)

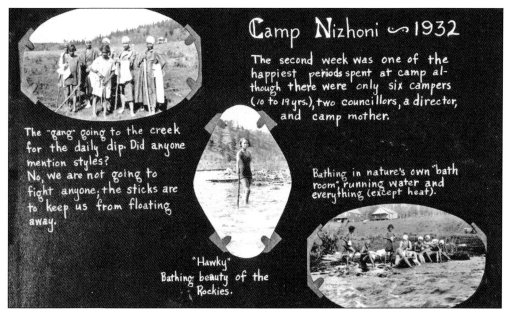

CAMP NIZHONI, PHYLLIS WHEATLEY YWCA, 1932. This montage from Camp Nizhoni shows various camp activities. These images were apparently taken during the second week of camp in 1932, with six campers, two counselors, a camp mother, and a director. The first photograph shows "the 'gang' going to the creek for the daily dip." The second one shows "Hawky, the bathing beauty of the Rockies." Hawky was Eleanor Hawkins, one of the camp staff. The third image shows the group "bathing in nature's own 'bathroom.'" (Courtesy Marie Anderson Greenwood.)

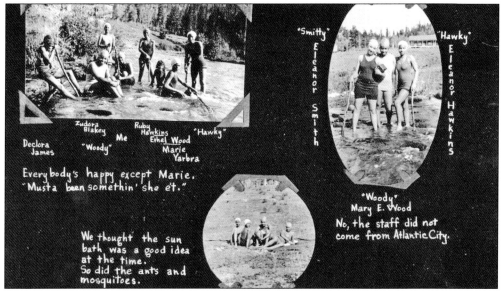

CAMP NIZHONI, 1932. Another montage from Camp Nizhoni in 1932 shows the girls and staff enjoying the water and sunbathing. Pictured in the first image are, from left to right, Declora James, Zudora Blakey, Mary E. "Woody" Wood, Marie Anderson Greenwood, Ruby Hawkins, Ethel Wood, Marie Yarbra, and Eleanor "Hawky" Hawkins. The second photograph shows three of the staff members, and some of the girls sunbathe in the third image. (Courtesy Marie Anderson Greenwood.)

FISHING ROD IN HAND. Ester Mae Barnett enjoyed fishing and hunting with her .22 either by herself or with her beloved daughter Maxine Satterwhite. (Courtesy Maxine Parks.)

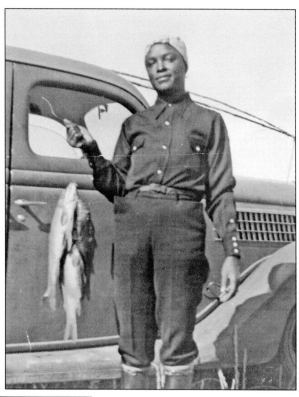

WILLIAM MOSES DABNEY. Born in 1870, Nicodemus, Kansas, pioneer William Dabney traveled to the Oklahoma Territory and worked at the famous XIT Ranch in the Texas panhandle, where he became a legend. Dabney homesteaded 100 acres of land south of Nicodemus, owning the largest herd of cattle and the finest horses in Graham County. In later years, Dabney moved to Denver with his eldest son Erwin. (Courtesy BAWM, Paul W. Stewart Collection.)

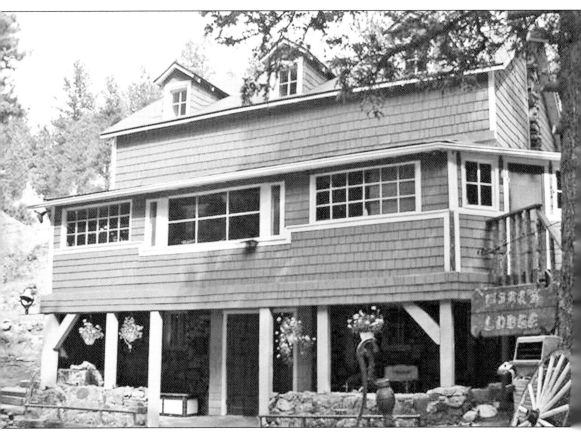

HISTORIC WINK'S LODGE. Gilpin County's Lincoln Hills was an African American mountain resort community founded in 1922. Parcels of land were sold to African Americans throughout the United States for $5 down and $5 a month until a total of $50 was accrued. By 1925, Obrey Wendell "Wink" Hamlet built Wink's Lodge at Lincoln Hills, hosting African American celebrities visiting Denver while vacationing in the mountains. Wink's Lodge was purchased and restored by the James P. Beckwourth Mountain Club. (Courtesy the James P. Beckwourth Mountain Club.)

"THE LADY DOCTOR." Throughout her career, Dr. Justina L. Ford faced the obstacles of being African American and a woman. However, "The Lady Doctor" persevered and served people of all races. Ford was banned from membership in the Colorado Medical Society, which was required to join the American Medical Association. Both memberships were required to practice medicine at Denver General Hospital. (Courtesy Gene Carter.)

MEDICAL OFFICE ON ARAPAHOE STREET. Dr. Justina L. Ford set up her medical office in a home located at 2335 Arapahoe Street. She also made house calls. Ford never turned anyone away, regardless of race or ability to pay. She served thousands of patients. (Courtesy Gene Carter.)

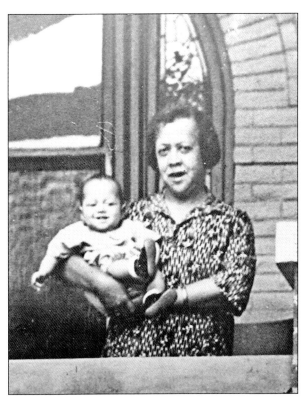

ONE BABY EVERY THREE DAYS. For 50 years, Dr. Justina L. Ford practiced obstetrics, gynecology, and pediatrics. Ford was still the only physician in Colorado to be both African American and female in 1950. Ford estimated that she delivered 7,000 babies, one every three days. Eventually, Ford was allowed to practice at Denver General Hospital. Dr. Ford is pictured here with her great-nephew Gene Carter. (Courtesy Gene Carter.)

DR. FORD. In 1952, Dr. Justina L. Ford was quoted as saying, "When all the fears, hate, and even some death is over, we will really be brothers as God intended us to be in this land." She is pictured here with her second husband, Alfred Allen, in front of their home on 2335 Arapahoe Street. The Ford Warren Branch Library is named in her honor. (Courtesy Gene Carter.)

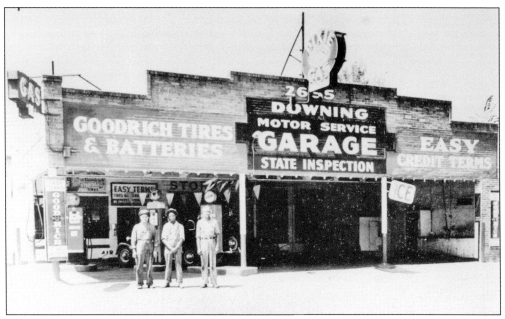

DOWNING MOTOR SERVICE. The Downing Motor Service was located at 2655 Downing Street. The gas station sold Dixie gas, Goodrich tires and batteries, state inspections, and ice. (Courtesy BAWM, Paul W. Stewart Collection.)

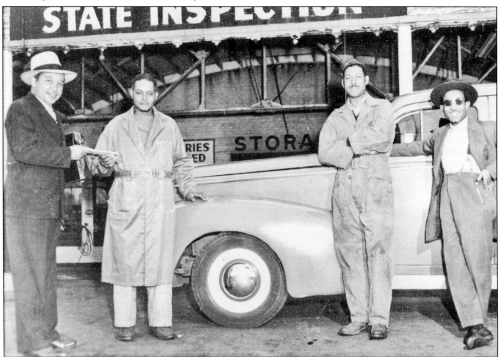

BILL L. WHITE. Bill L. White was the owner of Downing Motor Service, which was also a state inspection garage. Receiving state inspection papers after a service from Bill White (second from left) are L. Alfred Pinkard (left) and Nathaniel Scott (right). An unidentified worker is second from the right. (Courtesy BAWM, Paul W. Stewart Collection.)

ALONZO PETTIE. In 1947, Alonzo Pettie came to Denver to participate in Colorado's first all African American rodeo, which was developed by Alonzo Pettie and Willie "Smokey" Lornes. "High winds, clouds of dust, and some apathetic horse flesh failed to diminish the enthusiasm of a cheering, horn honking crowd of 500 yesterday afternoon sponsored by the Colored Rodeo Association of Denver." (Courtesy BAWM, Paul W. Stewart Collection.)

WILLIE "SMOKEY" LORNES, COWBOY. Denver's first African American rodeo was held in 1947. Smokey Lornes sponsored the rodeo to help some of the colored cowboys get a start and prove that the white people weren't the only ones to be able to successfully put on a show. (Courtesy BAWM, Paul W. Stewart Collection.)

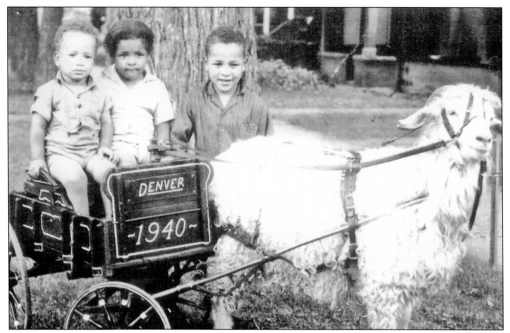

NEIGHBORHOOD PHOTOGRAPHER. Pictured here are the McLuster children: Clarence Robert (18 months), Anna Earlene (2.5 years old), and Joseph Wisdom (5 years old). A neighborhood photographer would go door to door and take photographs of neighborhood families for a small fee. Every family in the neighborhood had a picture of their children in this goat-driven wagon. (Courtesy Terri Lynne Smith Gentry.)

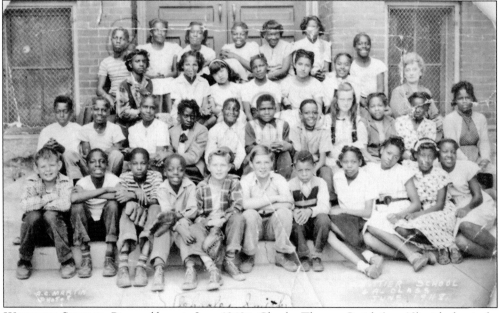

WHITTIER SCHOOL. Pictured here in June 1948 is Charles Thomas Smith (age 12) with the sixth-grade class at Whittier School. Smith is the third generation of the McClain-Smith family that migrated to Denver during the Great Migration of 1916–1919, a time when African Americans were leaving the South to escape Jim Crow laws. (Courtesy Terri Lynne Smith Gentry.)

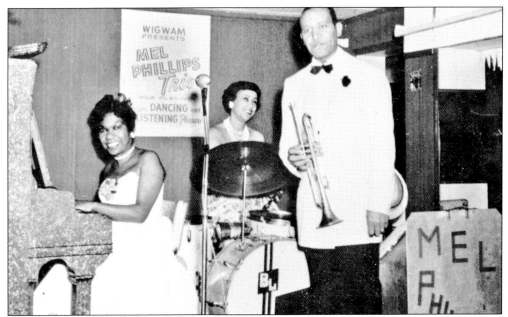

WIGWAM PRESENTS. Note the sign in the back, which states: "Wigwam Presents Mel Phillips Trio, Now Playing, for your Dancing and Listening Pleasure." Pictured from left to right are the Mel Phillips Trio: Charlotte Cowen on piano, Melvin Phillips on horn, and Louise Maxey Walker on drums. Cowen was born in Denver and began playing the piano at the age of three; Mary Lou Williams was her mentor. Duke Ellington helped Cowen refine her methods and style. (Courtesy BAWM, Paul W. Stewart Collection.)

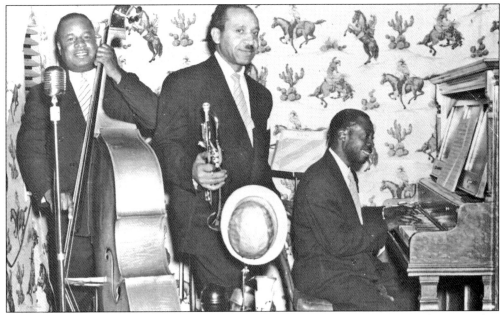

MEL PHILLIPS TRIO, 1945. The Mel Phillips Trio featured Charles Walker on bass, Elmer "Tuggles" Jones on piano, and Mel Phillips on trumpet. In addition to his work as a musician, Phillips was a photographer who left a pictorial record of local musicians, their bands, and the places they played. (Courtesy BAWM, Paul W. Stewart Collection.)

Seven
THOSE WHO SUFFER WRITE THE MUSIC

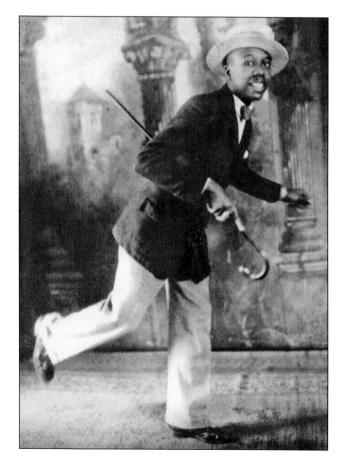

THOSE IN POWER WRITE THE HISTORY, THOSE WHO SUFFER WRITE THE SONGS. Orea Marshall, pictured here at age 16, was part of the Marshall Brothers group along with his two younger brothers, Harry and Walter. Orea and Harry were especially adept at writing, acting, and producing their own plays. (Courtesy BAWM, Paul W. Stewart Collection.)

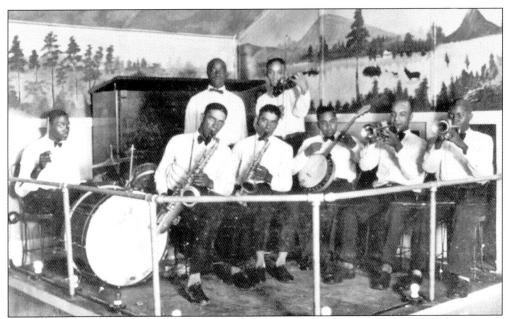

HOLMES BLUE MELODY ORCHESTRA. George Holmes's orchestra is pictured here playing at the Palm Night Club. Hoggie Harper is on the mandolin. Written on the photograph is "Holmes Blue Melody Orchestra now playing at the Palm Night Club, Denver, Colorado." (Courtesy BAWM, Paul W. Stewart Collection.)

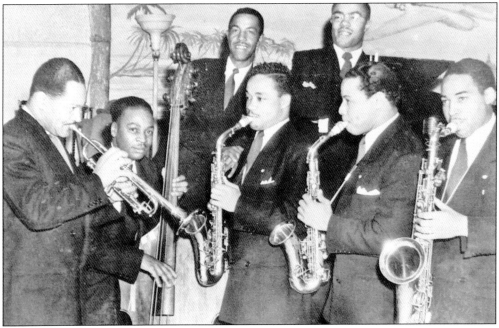

THE LEONARD CHADWICK BAND. Local musicians played at the Aeroplane Ballroom before they joined or were drafted into the armed services during World War II. Pictured here are, from left to right, (first row) Leonard Chadwick, trumpet; James Scott, bass; Beatty Hobbs, alto sax; Alyston "Soup" Campbell, alto sax; and Joe Gayles, tenor sax; (second row) Ulysses Woods, piano, and Spencer McCain, drums. (Courtesy BAWM, Beatty Hobbs.)

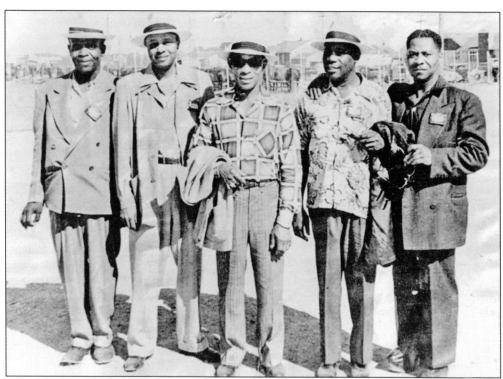

DENVER BANDLEADERS. African American musicians were hired to play during the week of the rodeo in Cheyenne, Wyoming. They traveled to the gig on Palmer Hoyt's (publisher of the *Denver Post*) special train to Cheyenne for Frontier Days. Notice that each man wears a badge identifying him as orchestra/guest of the *Denver Post*. Pictured from left to right are Joe Tate, Bill Durvin, Rudy Baldwin, Booker T. Christian, and Prince Albert Williams. (Courtesy BAWM, Paul W. Stewart Collection.)

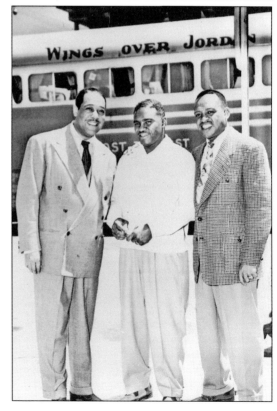

WINGS OVER JORDAN. From left to right, Duke Ellington, Dennis Lyles, and Lionel Hampton pose in front of the Wings Over Jordan bus in downtown Five Points. Wings Over Jordan was one of the country's most popular gospel singing groups in 1948. (Courtesy BAWM, Paul W. Stewart Collection.)

DENVER DANCER. Delno Polk, a Denver native, was an acclaimed singer and dancer who taught music to neighborhood children. (Courtesy BAWM, Paul W. Stewart Collection.)

PARADE FLOAT. Sitting on the parade float is Ester Mae Barnett, an active civic and social leader, and an unidentifed man. Barnett moved to Denver in the early 1940s. (Courtesy Maxine Parks.)

THE GRAND LADY OF THE GRAND PIANO. A nationally recognized musician, Denver's Louise Duncan was known as "Colorado's First Lady of Jazz." During her career, Duncan played with and for many musical greats, including Oscar Peterson, Nat King Cole, Duke Ellington, Ella Fitzgerald, and Billie Holiday. (Courtesy the Blair Caldwell African American Research Library.)

TURF CLUB. One of their business cards read, "Greetings from Dennis Lyles and Tune Tones featuring Louise, Crisp and Scottie." Arthritis had plagued Louise Duncan since she was 17, and in 1969, she was forced into retirement. Little by little, she rehabilitated herself and restarted her career in 1971, which lasted into the 1980s. Duncan passed away in March 1990. (Courtesy BAWM, Paul W. Stewart Collection.)

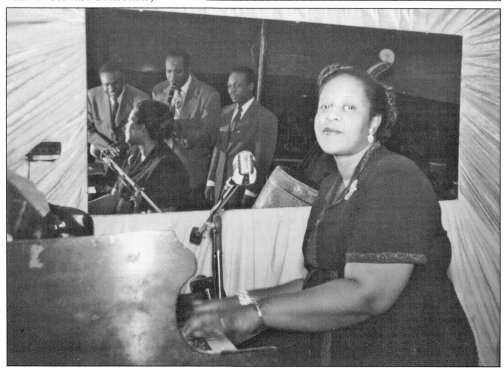

WORTH A THOUSAND WORDS. Burnis McCloud took photographs of almost every social activity in Denver for several decades and left a rich photographic history of African American life in Denver. The collection was donated to the Denver Public Library. (Courtesy Blair Caldwell African American Research Library, Burnis McCloud Collection.)

WEBSTER RUCKER. The Rucker brothers—Webster and Eddie—appeared in numerous musical performances over the years. Webster (pictured right) was the president of Musicians Local No. 623 for 50 years, and Eddie trained young musicians, many of whom became professionals. (Courtesy Jennie Rucker.)

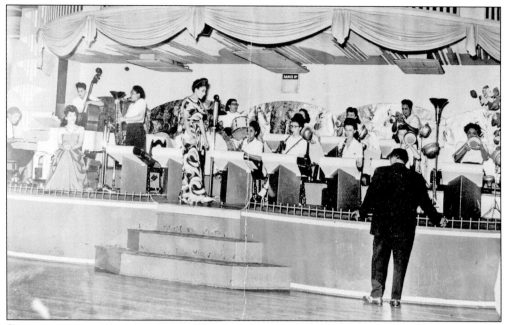

SWEETHEARTS OF RHYTHM, 1940. The Sweethearts of Rhythm played the Rainbow Ballroom and were the first African American female orchestra to travel internationally. Bandleader Anna Mae Winburn is at the microphone in this 1940 photograph. They also played at the Rossonian Hotel and Lounge. (Courtesy BAWM, Paul W. Stewart Collection.)

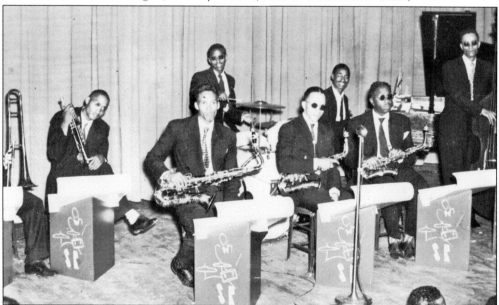

SHELLEY RHYM BAND, 1947. Shelley Rhym's band played at the old Casino Ballroom in 1947; the same year that Benny Hooper began construction on the new Casino Ballroom. Pictured are, from left to right, (first row) Robert White, alto sax and English horn; and Ellsworth Baker, tenor sax and clarinet; (second row) Gwen Davis, vocalist; Shelley Rhym, drums; Arthur Tidmore, bass; Julius Watkins, French horn and trumpet; Robert Jackson, trombone; and Jerry Bryant, piano. (Courtesy BAWM, Paul W. Stewart Collection.)

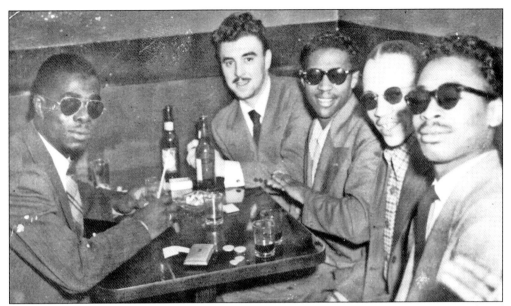

SHELLEY RHYM AND FRIENDS, 1940. Drummer and bandleader Shelley Rhym sometimes relaxed at the Rossonian Hotel and Lounge with friends and fellow musicians. Pictured from left to right are Arthur Tidmore, unidentified, Shelly Rhym, Bob White, and Jerry Bryant. (Courtesy BAWM, Paul W. Stewart Collection.)

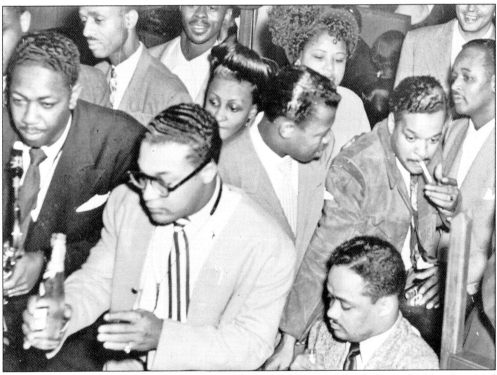

DENVER JAZZ MUSICIANS. Charles Sanbourne (wearing the striped shirt), Beatty Hobbes (pictured bottom, third from the left), and other fellow jazz musicians hang out at the Rossonian Hotel and Lounge. (Courtesy BAWM, Paul W. Stewart Collection.)

PAUL QUINICHETTE. Tenor sax PLAYER Paul Quinichette developed a style that had long lines and rhythmic sweeps, which pleased both music lovers and critics. Fans crowded the postage stamp–sized dance floor to dance to the music of the Quinichette Quintet. (Courtesy BAWM, Paul W. Stewart Collection.)

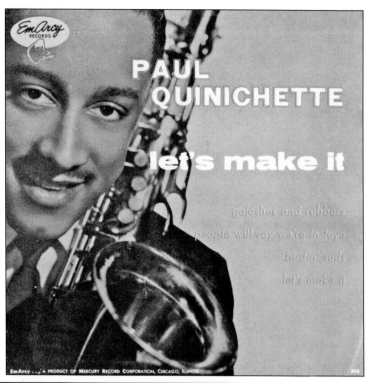

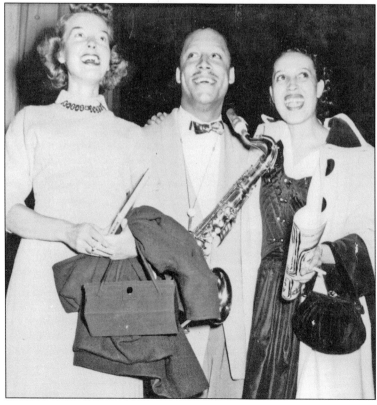

DENVER NATIVE. Paul Quinichette's record *Let's Make It* featured the title song "Let's Make It," which included the line "Let's make it, galoshes and rubbers, people will say we're in love, and bustin' suds." The Quinichette Quintet featured Paul Quinichette, tenor sax; Count Basie, piano; Joe Neuman, trumpet; Freddie Green, guitar; and Gus Johnson, drums. Let's Em Arcy Records in Chicago, Illinois, produced *Let's Make It*. (Courtesy BAWM, Paul W. Stewart Collection.)

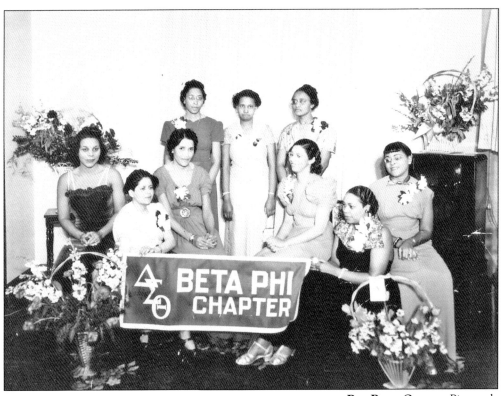

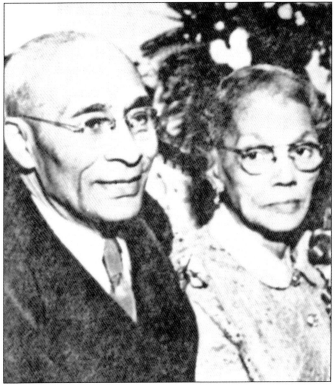

PHI BETA OMEGA. Pictured here are the founding members of the African American sorority Phi Beta Omega. (Courtesy Janell I. Lindsey, president, Denver chapter.)

FOR MY CHILDREN. Charles Cousins Sr. worked as a Pullman Porter for 33 years, saving one-tenth of his earning. Using his earnings, he built a duplex at Twenty-sixth Avenue and High Street in 1915. In 1924–1925, he built a six-unit apartment called Alta Cousins Terrace, named after his wife, and in 1929–1930, he remodeled 725 East Twenty-sixth Avenue. Cousins stated, "It's not for myself, but for my children." (Courtesy BAWM, Paul W. Stewart Collection.)

CHARLES "BROTHER" COUSINS JR. Charles Cousins Jr. attended Manual High School. White students' dances occurred in the gymnasium with a good sound system. Black events were held in a padded wrestling practice room. Cousins rigged up a sound system and rented it to students. When white-owned jukebox and vending businesses tried to take business from the places he had his products in, he would purchase the buildings. (Courtesy Charles Cousins.)

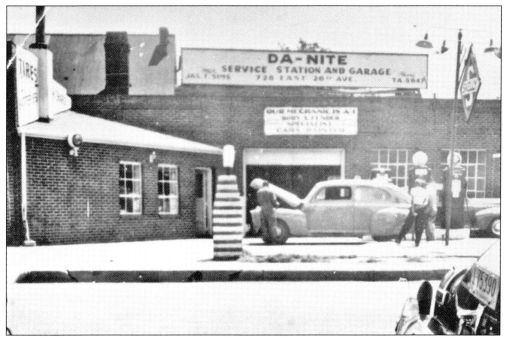

DA NITE SERVICE STATION. Located at 728 East Twenty-sixth Avenue, the Da Nite Service Station was managed by L. H. Smith. The station advertised "courteous and efficient service to all," which included mechanical repairs, a full-service filling station, and the convenience of free pick up and delivery of cars. (Courtesy BAWM, Paul W. Stewart Collection.)

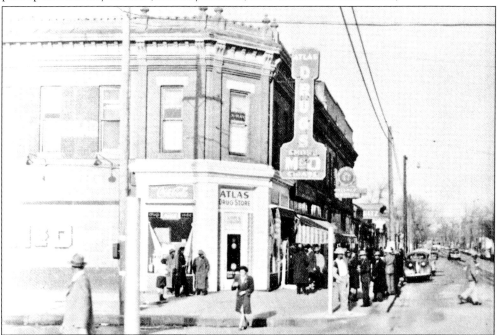

ATLAS DRUG STORE. Located at the corner of Twenty-seventh Avenue and Welton Street, the Atlas Drug Store was the only drugstore in Five Points where African Americans could sit at the fountain and enjoy a soda or ice cream. (Courtesy BAWM, Paul W. Stewart Collection.)

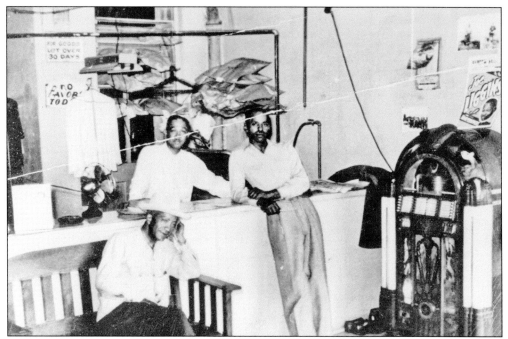

LUCKY FRED'S CLEANERS. Fred Gatewood was the owner of Lucky Fred's Cleaners, located at Twenty-sixth Avenue and Welton Street. Pictured from left to right are George Shepard (sitting on the bench), Fred Gatewood (behind the counter), and "Roscoe." Note the jukebox on the right side of the photograph. (Courtesy BAWM, Paul W. Stewart Collection.)

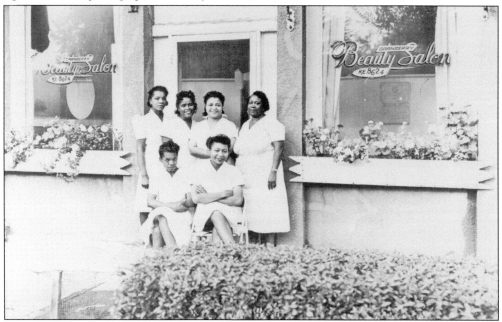

PERFECTLY COIFFED. THE Grandberry Beauty Salon was located at 2810 Downing Street. Pictured are the owners and beauty operators. From left to right are (sitting) Zepha C. Grant and Fannie Grandberry; (standing) Rose Grandberry, Lonnie Vonn Dickerson, Winifred McVey, and Mrs. Ware. (Courtesy BAWM, Paul W. Stewart Collection.)

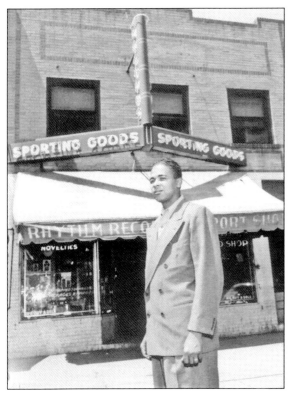

RHYTHM RECORD AND SPORTING GOODS SHOP. Leroy Smith moved to Denver in 1936. In 1944, he was the youngest 33rd degree Mason in Colorado. In 1945, he converted an apartment/office building into the Voter's Club in Five Points. Smith owned Rhythm Record and Sporting Goods Shop, the third largest sporting goods business in America, and became the deputy game warden in Colorado. (Courtesy Blair Caldwell African American Research Library.)

ROCKIN' WITH LEROY. Leroy Smith was the first African American disk jockey in Denver. Rockin' with Leroy was his midnight 30-minute show on station KFEL from 1948 to 1960. He paid for his airtime, brought his own records, and promoted the Rainbow Ballroom. Smith was the first African American to join the Denver Chamber of Commerce. (Courtesy Blair Caldwell African American Research Library.)

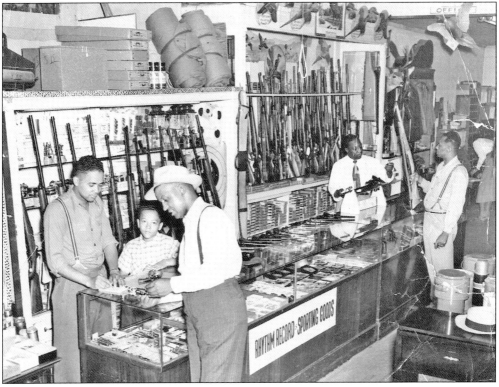

Eight
FOOT SOLDIERS FOR FREEDOM

ONE HUNDRED FOURTEEN YEARS OLD. Here Henry T. Hall is being interviewed on KLZ Radio in front of the Atlas Drug Store, located at the corner of Twenty-seventh Avenue and Welton Street. Born in 1860, Hall was a longtime Five Points resident and Colorado pioneer known for his colorful character. Hall resided at Twenty-seventh Avenue and California Street and lived to be 114 years. (Courtesy BAWM, Paul W. Stewart Collection.)

COUNCILMAN CALDWELL. In 1950, Elvin R. Caldwell was elected to the state legislature as the first black city councilman. He served as council president three times. Charles Cousins and Caldwell opened the historic Club 715 Restaurant and the Minute Spot. Caldwell later bought the Rossonian Hotel and Lounge. In 2003, the Blair Caldwell African American Research Library was dedicated to Omar Blair and Elvin Caldwell. (Courtesy Blair Caldwell African American Research Library.)

MAJ. THOMAS CAMPBELL, 1869–1957. At age 24, Thomas Campbell graduated from Howard University law school. Joining the military, he achieved the rank of major during the Spanish-American War. In 1904, he moved to Denver. Campbell founded the *Denver Independent*, a black newspaper. He also founded the Denver Urban League in 1919. Through his law practice, he became a champion of civil rights for blacks. (Courtesy BAWM, Lulu Jacobs Collection.)

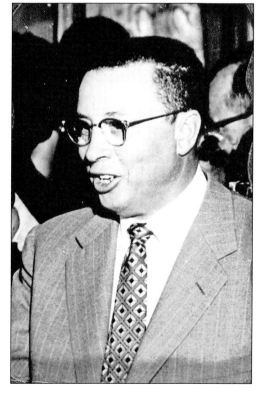

LITTLE ROCK NINE. The Little Rock Nine became foot soldiers for freedom in 1957. Carlotta Walls LaNier and eight other students integrated Central High School in Little Rock, Arkansas. LaNier moved to Denver in 1962 and earned her bachelor's degree from the University of Northern Colorado. She currently owns a real estate company. In 2007, LaNier returned to Central High School for the 50th anniversary of the school's desegregation. (Courtesy Colorado Women's Hall of Fame.)

ONLY CHILD. William Russell Fountain, born in 1936 to William and Sarah Fountain, graduated from East High School and earned a degree from the University of Denver in 1958. Fountain worked for the Colorado Department of Employment and Labor in the benefits files section and was a member of People's Presbyterian Church, serving as the secretary/treasurer of the church's Sunday school. (Courtesy BAWM, Fountain Family Collection.)

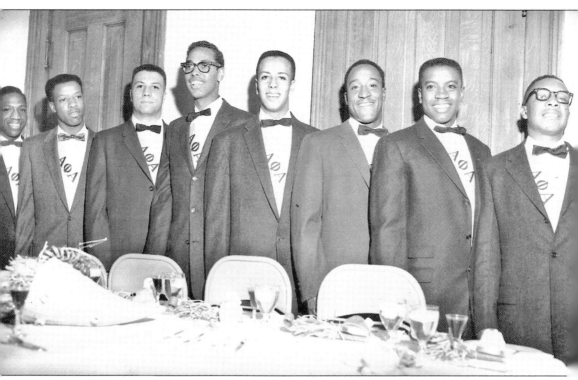

ALPHA PHI ALPHA FRATERNITY. Pictured here is the Alpha Phi Alpha spring dinner party in 1957. From left to right are two unidentified, Glen Harris, Jerome Page, Ottawa Harris, Ben Miller, Donnie Wilson, and Bob Williams. The dinner was hosted at Jerome Page's home in Denver. (Courtesy Jerome W. Page, McCloud Collection.)

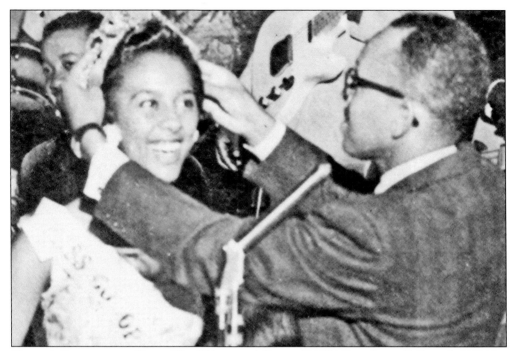

OMEGA'S SWEETHEART BALL. The fifth annual Omega Psi Phi Sweetheart Ball was held Friday evening, July 19, 1958. The contestants represented were JoKatherine Holliman and Jane Waller as "Ms. Colorado University," Janic Rozell as "Ms. Colorado State University," Hazel Miller as "Ms. Denver University," and Harriet Brock as "Ms. Colorado State College. Holliman was crowned the "Queen for a Day" and received many lovely presents. (Courtesy Burnis McCloud.)

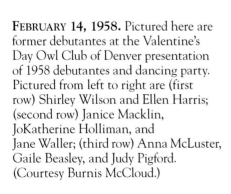

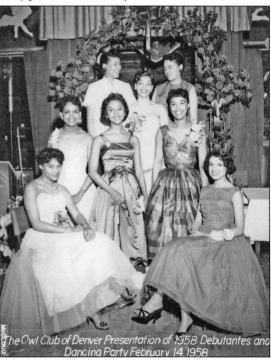

FEBRUARY 14, 1958. Pictured here are former debutantes at the Valentine's Day Owl Club of Denver presentation of 1958 debutantes and dancing party. Pictured from left to right are (first row) Shirley Wilson and Ellen Harris; (second row) Janice Macklin, JoKatherine Holliman, and Jane Waller; (third row) Anna McLuster, Gaile Beasley, and Judy Pigford. (Courtesy Burnis McCloud.)

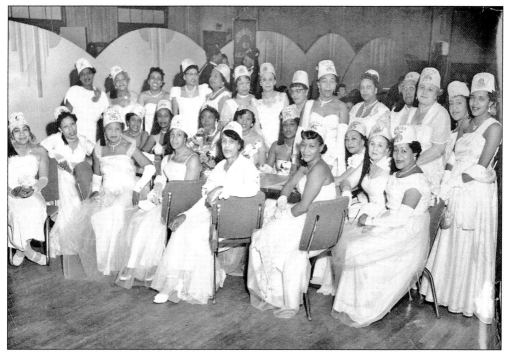

POTENTATES BALL, 1955. The Syrian Temple No. 49 of the Mystic Shrine hosted the annual Potentates Ball on February 22, 1955. (Courtesy Blair Caldwell African American Research Library.)

FIRE AND ICE BALL. The National Junior League hosts its Fire and Ice Ball c. 1958. The league is a civic servants and social group. (Courtesy Maxine Park.)

Nine
300 Miles to Victory

CASINO CABARET. Here, from left to right, (first row) Tommie Hawkins and Daisy Hawkins; (second row) Freddie L. Sanders, Jewelene Ellison, and James Polk enjoy an evening at the legendary Casino Cabaret located at 2637 Welton Street. (Courtesy Daisy Hawkins.)

LAUREN WATSON. The Black Panther Party (BPP) was a radical organization founded in 1966 in Oakland, California, by Huey P. Newton and Bobby Seale. The organization had chapters spread throughout the country. Lauren Watson led the Denver chapter of the Black Panther Party on Welton Street. Originally espousing a challenge to police brutality as a necessary means of achieving black liberation, the BPP called for a 10-point plan to liberate African Americans. (Courtesy Mary Lou Watson.)

INTEGRATION. Rachael Noel was the first African American woman elected to public office in Colorado. She was elected to a seven-member school board of the Denver Public Schools. Noel introduced the Noel Resolution, requiring total integration by December 1968. Public opposition did not discourage her. Although the new school board overturned the resolution in 1969, the suit to integrate Denver schools was eventually upheld by the U.S. Supreme Court. (Courtesy Ottawa Harris.)

GIVE US STRENGTH. Wellington Webb and other Colorado state legislators paused for a prayer before the opening of the session in 1972, the year Webb was first elected as a representative. (Courtesy Webb family.)

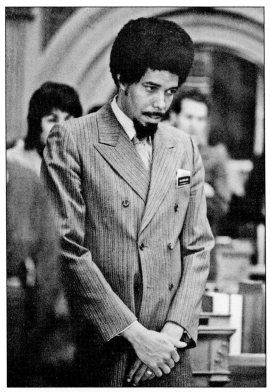

HISTORIC MAYORAL BID. Pres. Jimmy Carter appointed Wellington E. Webb as Region Eight director for the U.S. Department of Health and Human Services in 1977. In 1981, Colorado governor Richard Lamm appointed Webb to his cabinet as executive director of the Department of Regulatory Agencies. By 1987, Webb was elected Denver city auditor, and his track record paved the way for his successful and historic mayoral bid in 1991. (Courtesy Webb family.)

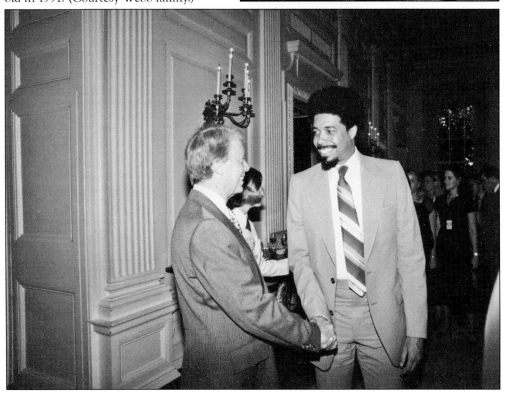

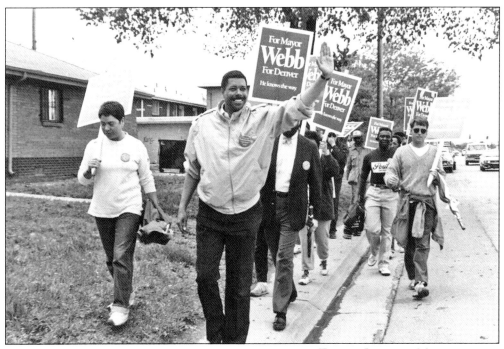

THREE HUNDRED MILES TO VICTORY. In 1991, Wellington Webb pledged to walk the entire city in his underdog bid for the mayor's seat, including during the city's annual Juneteenth parade in northeast Denver. Over 39 consecutive days, he walked more than 300 miles and lost 25 pounds, not once going home or getting into a car. (Courtesy Webb family.)

MILE HIGH CITY. During his three terms as mayor of Denver, Wellington Webb focused on four major areas: parks and open space, public safety, economic development, and children. Webb was president of the Democratic Mayors and the past president of the U.S. Conference of Mayors and the National Conference of Black Mayors. (Courtesy Webb family.)

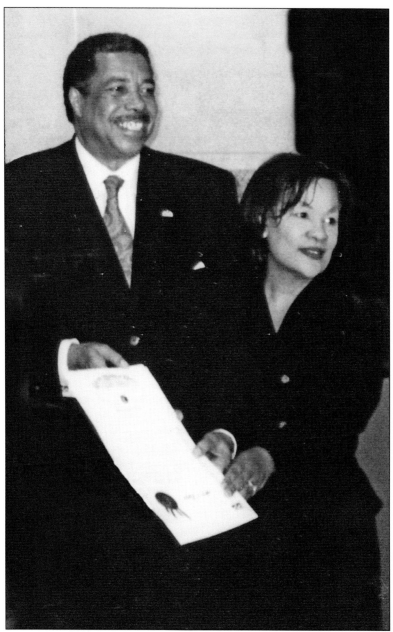

POLITICAL PIONEER. Wilma Webb was elected Democratic committeewoman in 1970. By 1980, she finished State Representative King Trimble's term in House District 8, introducing a controversial bill to establish a statewide holiday on Martin Luther King Jr.'s birthday, which was approved in 1984. Wilma Webb coined the term "marade" in 1986 after Gov. Richard Lamm signed House Bill 1201, making Martin Luther King Jr.'s birthday a legal holiday in Colorado. The term "marade" is composed of two words— march, meaning demonstrate, and parade, meaning celebrate. The marade begins at the Dr. Martin Luther King Jr.'s *I Have A Dream* monument in Denver's City Park and ends at the capitol. Wilma Webb is married to former Denver mayor Wellington Webb. She is the mother of four, including Denver's clerk and recorder Stephanie O'Malley. (Courtesy Webb family.)

THIRTY-SEVEN BUSES BOMBED. Omar Blair was the first black president of the Denver Board of Education. He held the position from 1972 to 1984. Blair desegregated the Denver Public Schools using court-ordered busing. Thirty-seven buses were bombed, and pro-busing board members received constant threats. Blair earned praise for his calming presence and community service. In 2003, the Blair Caldwell African American Research Library was named in his honor. (Courtesy Blair Caldwell African American Research Library.)

THREE-YEAR PROBATION. Marie Anderson Greenwood was hired in 1938 under a three-year probation for the Denver Public Schools when she accepted a job teaching first grade at Whittier Elementary. The school system stipulated that they would not hire other African Americans until she passed her probationary period. After passing that probationary period, the doors were opened to others. Greenwood is the author of *Every Child Can Learn*. (Courtesy BAWM.)

SUNS OF DARKNESS LEADER. Alvin Maxie grew up in Louisiana and spent 12 years in the army, where he learned to speak German fluently and earned a black belt in karate while in Korea. Maxie had a fondness for wide-open spaces and moved to Colorado, where he formed the organization Suns of Darkness. The group, which places family first, has hosted the Easter egg hunt in City Park for over 30 years. (Courtesy BAWM, Alvin Maxie Collection.)

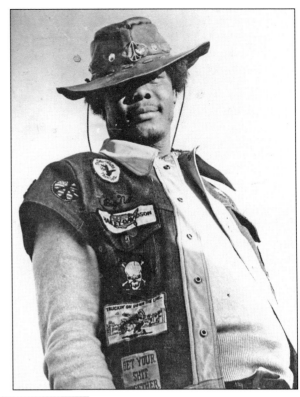

BISCUITS. Mildred Pitts Walter, an author, activist, and educator, published her first book, *Lily of Watts-A Birthday Discovery*, in 1969. She is the recipient of the 1987 Coretta Scott King Award for Literature for her book *Justin and the Best Biscuits in the World*. Walter, along with Shirley Sims and Hazel Whitsett, founded the Northeast Women's Center located on East Thirty-eighth Avenue in Denver. (Courtesy Colorado Women's Hall of Fame.)

Dr. Daddy-O. James (Dr. Daddy-O) Walker was the owner of KDKO Radio 1510. Walker's proudest accomplishment was acquiring KDKO Radio, providing jobs for more than 30 people and allowing them an opportunity to display their talents. He enjoyed the title of owner and was proud to provide a broadcasting service to the community. (Courtesy BAWM, Paul W. Stewart Collection.)

Women's Air Force. Arie Parks Taylor pursued an education at Miami University in Ohio and then joined the Women's Air Force (WAF), becoming the first African American noncommissioned officer in charge of WAF training. She moved to Denver in 1958. In 1972, Taylor became the first African American woman elected to the Colorado State House of Representatives as clerk and recorder chief clerk of the Denver Election Commission. (Courtesy Colorado Women's Hall of Fame.)

ESTES PARK. Jess E. Dubois graduated from the inaugural class of the Art Institute of Colorado in 1957. As a Creole of Cherokee ancestry, Dubois is passionate about Native American art. Dubois owned a gallery in Estes Park, Colorado, until he was forced to close it following the town's devastating 1982 flood. Returning to his native Five Points neighborhood, According to Dubois, he used his art to "project the soul of his subjects onto canvas." (Courtesy BAWM.)

MINORITY CAUCUS. A lifetime of political activism has earned Gloria Tanner many awards, distinctions, and titles. She was the first African American woman to serve as a Colorado state senator and the second African American to be elected to a leadership position in the Colorado House of Representatives, where she was chair of the Minority Caucus. (Courtesy Colorado Women's Hall of Fame.)

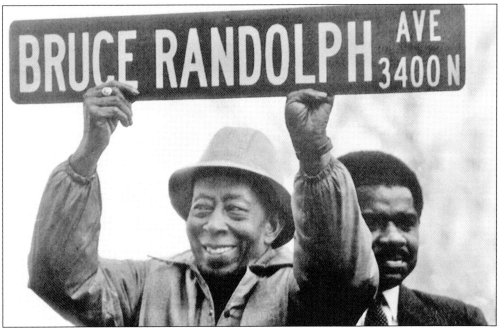

THANKSGIVING DINNER. Each year, "Daddy" Bruce Randolph provided 20,000 people with holiday meals. Standing behind Randolph is Councilman Hiawatha "Hi" Davis, a Denver native who dedicated his life to human and civil rights. For 16 years, Davis served on the Denver City Council representing District 8, which included Five Points. Davis passed away on May 24, 2000, after battling prostate cancer. (Courtesy Blair Caldwell African Americans Research Library.)

PEOPLE TO WATCH. Elbra Wedgeworth, a Denver native, served all three branches of city government: the city council, the city auditor's office, and the mayor's office. In 2001, the *Denver Business Journal* selected her as one of the eight outstanding Women in Business. *5280* magazine identified her as one of the "22 People to Watch." Wedgeworth was elected city council president in 2003. She was also the president of the Denver Host Committee for the 2008 Democratic National Convention. (Courtesy Dee McGee.)

JAMES TUCKER. A father, teacher, war veteran, and activist, James Tucker is past president of the Colorado Springs chapter of the NAACP and the Colorado-Wyoming-Montana conference of the NAACP. He is currently the publisher/CEO of the *African American Voice* newspaper, the largest black monthly newspaper, which serves Pueblo, Colorado Springs, and Denver. Tucker is also a tireless crusader for justice and equality. (Courtesy James Tucker.)

VOICE FOR THE COMMUNITY. Rosalind "Bee" Harris is the founder, publisher, owner, and art director of the *Denver Urban Spectrum* newspaper. In providing a voice for the community, the *Denver Urban Spectrum*'s moto has been "spreading the news about people of color." It has done so for more than 20 years, attracting 60,000 readers every month. Bee Harris is an active member in the community, with memberships and organizational affiliations. (Courtesy Rosalind "Bee" Harris.)

CLEO PARKER ROBINSON. The executive artistic director of the Cleo Parker Robinson Dance Ensemble is a Denver native and renowned choreographer. Overcoming nephritis, kidney failure, a heart attack, and ulcers in childhood, Robinson received formal dance training at Colorado Women's College and performed with the Alvin Ailey Dance Center and Arthur Mitchell's Dance Theatre of Harlem. She established the Cleo Parker Robinson Dance Ensemble in 1970. (Courtesy Colorado Women's Hall of Fame.)

THE STILES AFRICAN AMERICAN HERITAGE CENTER. Grace Stiles is the founding director of the Stiles African American Heritage Center. Stiles retired after 23 years of teaching in the Denver Public Schools system and created the heritage center as an outgrowth of African American History on Wheels in 1992. The heritage center is located at 2607 Glenarm Place in Five Points. (Courtesy Stiles African American Heritage Center.)

GREATEST SHOW ON DIRT. Lu Vason is president and producer of the Bill Pickett Invitational Rodeo, the only traveling black rodeo in the country. After attending the granddaddy of rodeos in Cheyenne, Vason said his rodeo experience "was exciting but lacked one thing, black cowboys." He organized the first Bill Pickett Invitational Rodeo in 1984 in Denver. Today nine rodeos organized by Vason are held in city arenas and fairgrounds across the country. (Courtesy BAWM.)

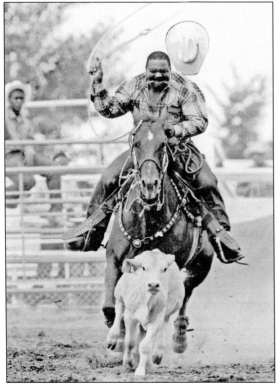

"MOE BETTA." Maurice "Moe Betta" Wade was honored as Rookie of the Year at the Bill Pickett Invitational Rodeo's "Salute to the Black Cowboy" in 1985. By 1989, Wade became a member of the Professional Rodeo Cowboys Association (PRCA), where he competes in tie-down calf-roping events. He is employed by the U.S. Department of Agriculture, Food, and Nutrition, and teaches about the history of black cowboys. (Courtesy Maurice "Moe Betta" Wade.)

BROTHER JEFF'S CULTURAL CENTER AND CAFÉ. A native of Northeast Denver, Jeff S. Fard, better known as Brother Jeff, is a writer, poet, cultural critic, community organizer, and entrepreneur. In demand on the national lecture circuit, Brother Jeff speaks to youth, students, community organizations, and health care professionals about cultural identity, history, diversity, self-empowerment, community building, economic development, health disparities, and the arts. (Courtesy Brother Jeff's Cultural Center and Café.)

PUBLIC SERVANT. Vern L. Howard is the operations supervisor for the Department of Parks and Recreation for the city and county of Denver and the chairman of the MLK Colorado Holiday Commission. Howard organized Denver's Olympic Torch passage, the Denver Public Library grand reopening, and the dedication to the community of the Blair Caldwell African American Research Library. He also coordinated volunteer training for Katrina relief efforts. (Courtesy Vern Howard.)

AFRICAN AMERICAN LEADERSHIP INSTITUTE (AALI). The AALI started as a vision of Larry Borom, president of the Urban League of Metropolitan Denver. Later Metropolitan State College of Denver professors Thomas Brewer, David Williams, and Ronald Knights addressed concerns of African Americans by encouraging the coordination, cooperation, and efforts of organizations to increase the industrial, economic, social, educational, and spiritual well-being of the African American community. (Courtesy African American Leadership Institute.)

RETURN TO THE SOURCE. The Sankofa Arts Collective is a group of 25 African American artists living and working in the historic Five Points neighborhood. Sankofa's Back Do' Studio was so named to honor those who historically had to enter the back door entrance of business establishments at a time when that was all they were allowed to do. Sankofa welcomes all into its Back Do' Studio. (Courtesy Sankofa Arts Collective.)

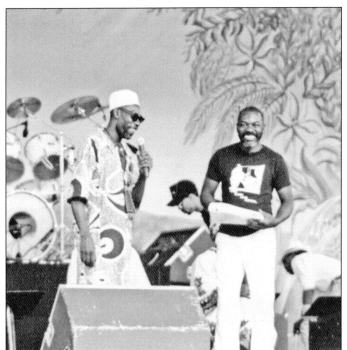

Denver Black Arts Festival. Perry Ayers, his brother Oye Oginga, and a small contingent of artists and art lovers created the Denver Black Arts Festival in 1986. The first festival occurred in 1987, and it rained for two days straight. By 1990, the crowd reached 60,000; in 1991, more than 100,000 people attended. It is one of the premiere festivals in the nation. (Courtesy Perry Ayers and Oye Oginga.)

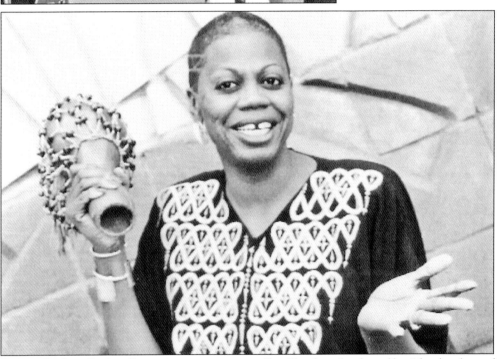

Griot. Opalana Pugh is Denver's grassroots storyteller. She describes herself as "the daughter of the dust of Five Points," sharing wisdom through modern and traditional stories and songs from various African cultures. Pugh is single and claims all of the children of her community as her own. She states, "When you're single, it's like being married to my community, and what I raise is culture." (Courtesy Opalana Pugh.)

A PRIVATE GUIDE. Sid Wilson, president of A Private Guide, Inc., serves as a Denver Public Library commissioner and was a member of the board of directors of the Denver Metro Convention and Visitors Bureau, the Black American West Museum, the Colorado Historical Society, Historic Denver, and the James P. Beckwourth Mountain Club. Born in New York, Wilson is married to Claudia Marie, has two children, and is a Vietnam veteran. (Courtesy Sid Wilson.)

JAMES P. BECKWOURTH MOUNTAIN CLUB (JPBMC). Pictured here are Beckwourth Outdoor Education Center youth leaders at Lake Ann in August 2006. Members of the JPBMC hike, camp, backpack, climb mountains, fish, white-water raft, canoe, kayak, cross-country ski, and snowboard. (Courtesy James P. Beckwourth Mountain Club.)

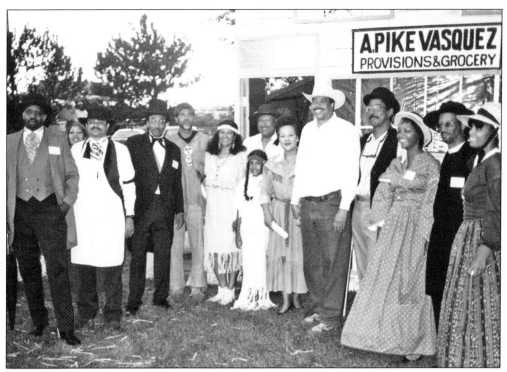

PLATTE RIVER MAYOR. Pictured here is Mayor Wellington Webb, wearing a white cowboy hat. To Webb's right is Wilma Webb and the James P. Beckwourth Mountain Club (JPBMC) historical reenactors at Denver's 1997 Platte River Rendezvous. More than just a "mountain club," JPBMC offers an award-winning mentoring/leadership development program for Denver urban youth, as well as history programs that educate the public about the contributions made by people of color in the West. (Courtesy Michael Richardson.)

JOHN BELL. The Buffalo Soldiers of the American West began as the result of an oversight in the history of the West. John Bell participated in reenactments in Colorado and noticed a lack of representation of the buffalo soldiers, so in 1986, Bell organized the Buffalo Soldiers of the American West. Each year, thousands of people are educated about African Americans of the West. (Courtesy La Wanna M. Larson.)

FOXY BROWN. Pam Grier was born on May 26, 1949, in Winston-Salem, North Carolina. The daughter of an air force mechanic, Grier was raised on military bases in England and Germany before her family settled in Denver. At the age of 18, Grier entered the Miss Colorado Universe pageant, where she was first runner-up. The reigning queen of the 1970s blaxploitation genre, Grier starred in *Coffy* (1973) and *Foxy Brown* (1974). She also played the 1975 sex symbol in *Sheba, Baby* and was the titular reporter in *Friday Foster*. Other films to her credit include *Above the Law*, *Original Gangstas*, and *Jackie Brown*. (Courtesy Rosalind "Bee" Harris, *Denver Urban Spectrum* archives.)

FOUR GRAMMY AWARDS. Dianne Reeves was born on October 23, 1956, in Detroit, Michigan, to a musical family. She and her sister were raised by their grandmother in Denver. At the age of 16, her uncle, Charles Burell, a bass player with the Denver Symphony Orchestra, introduced Dianne to jazz. Reeves is considered an important contemporary jazz singer, having won four Grammy Awards for "Best Jazz Vocal Performance" for her albums *In the Moment*; *The Calling*; *A Little Moonlight*; and *Good Night, and Good Luck*. She is the only performer to have won this award for three consecutive recordings. (Courtesy Rosalind "Bee" Harris, *Denver Urban Spectrum* archives.)

COLORADO'S HIGHEST-RANKING AFRICAN AMERICAN. Peter C. Groff is the first African American state senate president in Colorado history and only the third in U.S. history. Senator Groff is the highest-ranking African American official in Colorado. He is the founder and executive director of the University of Denver Center for African American Policy. Groff became Colorado's sixth African American state senator when he was appointed to the Colorado State Senate on February 10, 2003. (Courtesy Peter C. Groff.)

GOLDEN GLOBE AWARD. Don Cheadle was born on November 29, 1964, in Kansas City, Missouri, to a psychologist father and bank manager mother. During his early childhood, his family moved to Denver, where he attended East High School. Cheadle, an Academy Award–nominated and Golden Glove Award–winning actor, got his start playing the role of Rocket in the 1988 film *Colors*. However, he was not noticed until he played Mouse Alexander in *Devil in a Blue Dress*. Other films to his credit include *Rosewood*, *Hotel Rwanda*, and *Crash*. (Courtesy Rosalind "Bee" Harris, *Denver Urban Spectrum* archives.)

Ten
Turning Disadvantages into Advantages

Civil Technology. Civil Technology, Inc., with Sheila King, president, and Carl Bourgeois, business manager, has redeveloped the King Stroud Building, Kimball Hall, Kings Island, and the Rossonian. Civil Technology, Inc., provides construction management expertise to the completion of major projects, such as the Denver Art Museum, the Denver Convention Center Hotel, the Wellington Webb Office Building, the Stapleton Redevelopment Project, and the Denver International Airport. (Courtesy Sheila King and Carl Bourgeois.)

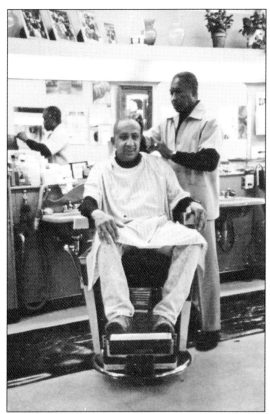

COMMUNITY FATHER. Dee McGee is the owner of New Look Barbers, located in Five Points on 2825 Welton Street. His barbershop has provided a nurturing place for Five Points' residents. McGee supports many community organizations and is the three-time former president of the Five Points Business Association. The Juneteenth celebration was one of the great events sponsored by Five Points Business Association. (Courtesy Dee McGee.)

DANCE, DANCE, DANCE. George Washington Gray Jr. was born October 5, 1911. He moved to Denver in 1944. Gray is a member of the Prince Hall Rocky Mountain Lodge No. 1, the Scott United Methodist Church, and a 32nd degree master Mason. Gray annually hosts Denver's Father and Son Communion Breakfast. For exercise, Gray dances at various city park jazz festivals, social functions, and special events in town. (Courtesy BAWM.)

BLACK AMERICAN WEST MUSEUM. In 1984, the home of "Lady Doctor" Dr. Justina L. Ford was slated for demolition. However, the home was moved from 2335 Arapahoe Street to 3091 California Street and became the new home of the Black American West Museum (BAWM). The museum is dedicated to African American men, women, and children who ventured westward. BAWM exhibits photographs and artifacts from black pioneers, buffalo soldiers, mountain men, homesteaders, cowboys, and military heroes. (Courtesy BAWM.)

BLACK COWBOY. In 1971, Paul W. Stewart founded the Black American West Museum. As a child, Stewart loved to watch Westerns and play cowboys and Indians, always playing the Indian because he was told there was no such thing as a black cowboy. It was not until the early 1960s, while visiting a cousin in Colorado, that Stewart saw a black cowboy. Stewart eventually moved to Denver and practiced his trade as a barber. His clients shared stories of their lives as African American miners, cowboys, homesteaders, fur traders, and pioneers as he cut their hair. (Courtesy Paul W. Stewart family collection.)

PIED PIPER. Paul W. Stewart scoured nearly every corner of the West to collect personal artifacts, memorabilia, newspapers, legal documents, clothing, letters, photographs, and oral histories. Since 1975, he has served as a consultant to the Denver Public Schools. He is affectionately known as the "Pied Piper of Black Western History," educating tens of thousands of students. (Courtesy Paul W. Stewart family collection.)

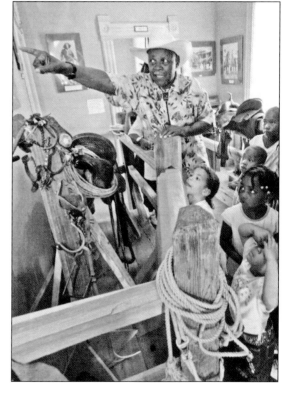

HONORING A LIFETIME. Rachel B. Noel was an associate professor at Metropolitan State College of Denver from 1969 to 1980, and she was the first female department chair. Noel served in the African and African American Studies (AAAS) Department from 1971 to 1980. Pictured are, from left to right, (first row) former department chairs Dr. Ronald J. Stephens and professor emeritus Rachel Noel; (second row) Dr. C. J. White and Dr. Akbarali Thobhani, acting chair of the department. Dr. Wilton Flemon (not shown) is the founding chair of the department. Due primarily to his efforts, Flemon was successful in persuading Metro State to institute a Rachel B. Noel Distinguished Visiting Professorship Program in 1981. To date, the program has acknowledged the achievements of scholars like Cornel West and Denver's performing artist Diana Reeves. (Courtesy This Week@Metro, Metropolitan State College of Denver; photographer, Julie Strasheim.)

EXECUTIVE DIRECTOR.
La Wanna M. Spann-Larson grew up in Colorado Springs, Colorado, and as a young girl, she enjoyed learning about Colorado history. In the fifth grade, her mother made prairie dresses for her daughters. Although the girls proudly wore their prairie dresses to school, the other children teased them and said there were no black pioneers. When they questioned their teachers, they stated African Americans did not live in the West. Puzzled, they went home to their parents, who began to share stories of their childhood—their mother lived on a ranch in a log cabin and their father grew up on a farm. These stories sparked their long passion for black history. Larson is the executive director of the Black American West Museum. (Courtesy BAWM.)

CHARLESZINE "TERRY" NELSON. Born and raised in Denver, Terry Nelson attended Manual High School, earned a bachelor's degree in Sociology and Psychology from the University of Colorado at Boulder, and earned a master's degree in Information Technology and Library Science from Emporia State College. Nelson is an author, an archivist, and the special collection and community resource manager for the Blair Caldwell African American Research Library. (Courtesy Terry Nelson.)

BIBLIOGRAPHY

Abbott, Carl, Stephen Leonard, and David McComb. *Colorado: A History of the Centennial State.* Third edition. Niwot, CO: University Press, 1994.

Alweis, Dick. *Rebels Remembered: The Civil Rights Movement in Colorado.* The Alice G. Reynolds Memorial Fund, 2007.

Betts, Donnie L. *Dearfield: The Road Less Traveled.* No Credits Production, Inc.

Durham, Philip, and Jones J. Everett. *The Negro Cowboys.* Lincoln, NE: University of Nebraska Press, 1965.

Holley, John Stokes. *The Invisible People of the Pikes Peak Region: An Afro-American Chronicle.* Colorado Springs, CO: The Friend of the Piles Peak Library and the Friends of the Colorado Springs Pioneers Museum, 1990.

Katz, William Loren. *The Black West: A Documentary and Pictorial History of the African American Role in the Westward Expansion of the United States.* New York: Harlem Moon, 2005.

Leckie, William H. *Buffalo Soldiers: A Narrative of the Black Cavalry in the West.* Norman, OK: University of Oklahoma Press, 1967.

Lohse, J. B. *Justina Ford: Medical Pioneer.* Palmer Lake, CO: Filter Press, LLC, 2004.

Love, Nate. *The Life and Adventure of Nate Love.* Lincoln, NE: University of Nebraska Press, 1995.

Mauck, Laura. *Five Points Neighborhood of Denver.* Charleston, SC: Arcadia Publishing, 2001.

Noel, T. J., with a foreword by Denver mayor Wellington Webb. *Denver Landmarks and Historic District: A Pictorial Guide.* Boulder, CO: University Press of Colorado, 1996.

Purdue, Fray Marcos, and Paul W. Stewart. Edited and compiled. *Westward Soul.* Denver, CO: Black American West Museum, Inc., 1982.

Rocky Mountain Legacy–Jazz in Five Points. Denver, CO: Rocky Mountain Public Broadcasting Network, Inc., 1995.

Simmons, R. Laurie, and Thomas H. Simmons. *Denver Neighborhood History Project, 1993–1994: Five Points Neighborhood.* Prepared for the City and County of Denver, Denver Landmark Preservation Commission, and Office of Planning and Community Development. Denver, CO: Front Range Research Associates, 1995.

Stewart, Paul W., and Wallace Yvonne Ponce. *Black Cowboys.* Denver, CO: Phillips Publishing, 1986.

Taylor, Quintard. *In Search of the Racial Frontier: African Americans in the American West, 1528-1990.* New York: W. W. Norton and Company, 1998.

Taylor, Quintard, and Shirley Ann Wilson Moore, ed. *African American Women Confront the West, 1600–2000.* Norman, OK: University of Oklahoma Press, 2003.

Discover Thousands of Local History Books
Featuring Millions of Vintage Images

Arcadia Publishing, the leading local history publisher in the United States, is committed to making history accessible and meaningful through publishing books that celebrate and preserve the heritage of America's people and places.

Find more books like this at
www.arcadiapublishing.com

Search for your hometown history, your old stomping grounds, and even your favorite sports team.

Consistent with our mission to preserve history on a local level, this book was printed in South Carolina on American-made paper and manufactured entirely in the United States. Products carrying the accredited Forest Stewardship Council (FSC) label are printed on 100 percent FSC-certified paper.